THE FIELD GUIDE TO PHOTOGRAPHING

FLOWERS

CENTER FOR NATURE
PHOTOGRAPHY SERIES

ALLEN ROKACH
AND
ANNE MILLMAN

AMPHOTO
AN IMPRINT OF WATSON-GUPTILL
PUBLICATIONS/NEW YORK

To the memory of ERNST HAAS,

a master photographer, who taught all

who knew him the joy of using a camera

to reveal nature's hidden beauty

PICTURE INFORMATION:
Page 1. Primrose. Anza Borego State Park, California.
Pages 2-3. Tulips. Holland.
Page 5. Tulips. The New York Botanical Garden.
Page 6. Poppies and daisies. Israel.

The Appendix material was first published in *Focus on Flowers*
by Allen Rokach and Anne Millman (Abbeville Press).

Senior Editor: Robin Simmen
Editor: Liz Harvey
Designer: Bob Fillie, Graphiti Graphics
Graphic-production Manager: Hector Campbell

Text by Allen Rokach and Anne Millman
Photographs by Allen Rokach

Library of Congress Cataloging in Publication Data
Rokach, Allen.
 The field guide to photographing flowers/by Allen Rokach
and Anne Millman.
 p. cm. — (Center for Nature Photography series)
 Includes index.
 ISBN 0-8174-3870-X
 1. Photography of plants. I. Millman, Anne. II. Title.
III. Series: Rokach, Allen. Center for Nature Photography series.
TR724.R648 1995 94-36839
778.9'34—dc20 CIP

ACKNOWLEDGMENTS:
No book is ever the product of the
authors alone. Many behind-the-
scenes players assist every step of
the way, from conception to birth.
Therefore, we thank the many
"midwives" who helped bring this
book to life.

Our gratitude goes first to Mary
Suffudy, a friend and inspiration, who
planted the idea of producing this
series of books based on her knowl-
edge of the workshops we were run-
ning for the Center for Nature Photo-
graphy. Her faith in the project got
it off the ground. We also thank Liz
Harvey, our editor at Amphoto, for
patiently guiding us as these books
took shape, keeping us on track
through a host of interruptions. We
greatly appreciate the encouragement
given to us by our friends at
Olympus America: Dave Willard,
John Lynch, Bill Schoonmaker, Pas-
quale Ferazzoli, and Marlene Hess.

Many thanks go to Kathy Barbour
at Thai Airways International, Nat
Boonthanakit and Suraphon Svetasveni
at the Tourism Authority of Thailand,
Barbara Veldkamp at the Netherlands
Board of Tourism, Barbara Cox and
Adam Leavitt at Royal Cruise Line,
and Priscilla Hoye at Cunard, for
enabling us to gather a wide assort-
ment of images for this book.

Special thanks to Bert Shanas, a
colleague and friend, who always
understood the pressures of serving
several masters and made working
under his direction easy, and to Frank
Kecko, an invaluable companion and
adviser on the many long field trips
we shared in search of flowers.

And who can say enough to the
many friends who held our hands and
soothed our frayed spirits during the
long gestation: Susan Amlung, Zvi
Galil, Dana Lehrman, Neil Rosenfeld,
Cathy Schwartz, and Tony Stavola.
Their interest and support made the
labor pains bearable.

Finally, we thank Kay Wheeler,
Sidney Stern, and Liz Barry, whose
assistance in keeping the photogra-
phy studio running smoothly freed us
for the effort this project demanded.

Contents

	INTRODUCTION	6
CHAPTER 1:	IMAGINE THE POSSIBILITIES	8
CHAPTER 2:	UNDERSTANDING NATURAL LIGHT	26
CHAPTER 3:	SHAPING AN AESTHETIC DESIGN	48
CHAPTER 4:	TOOLS AND TECHNIQUES	66
CHAPTER 5:	SHOOTING FROM A DISTANCE	84
CHAPTER 6:	FLORAL VIGNETTES	92
CHAPTER 7:	FLORAL CLOSEUPS	102
CHAPTER 8:	FLOWERS IN THEIR SETTINGS	110
	APPENDIX: FLASH DETERMINATIONS	126
	INDEX	128

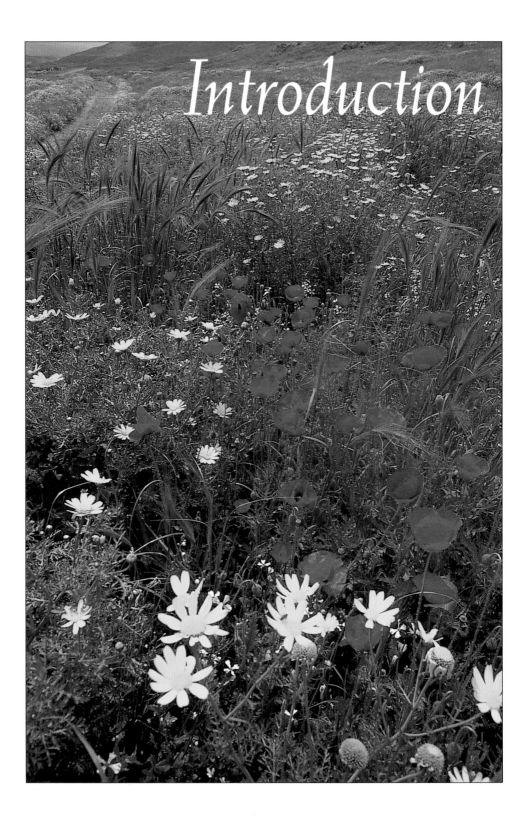

Introduction

Ten years ago, we decided that what New York City needed was a chance to rediscover the joy of photographing nature. And so we started the Center for Nature Photography. The idea was to alert urban residents to the many natural environments around them and to teach them how to capture these places on film. It was a mad idea, no doubt. Mention wildlife in New York and most people think you're referring to muggers. As Howard Chapnik, a giant in contemporary photojournalism, wrote at the time, this was a city known as "the center of sex, sin, rapacity, and greed." How could a center for nature photography take root in such an inhospitable landscape?

It wasn't easy. We started with weekend field trips and evening lecture series. Together, these attracted the first of many students who clearly found the prospect of immersing themselves in the wonders of the natural world using a camera intriguing. We explored bird sanctuaries at Jones Beach, Jamaica Bay, and Brigantine. We discovered the coastal landscapes of Pelham Bay Park and the Rye Marshlands. We followed the foliage from Central Park to Ward Pound Ridge, and we pursued flowers from Fire Island to Innisfree. Either within New York City or a short drive away, we found an endless variety of subjects to shoot.

But we soon began getting requests for longer excursions to locations beyond the city. Our students wanted to hone their skills in national parks or in more dramatic natural environments. Slowly, we added these to our roster, taking groups on week-long workshops in Maine, Colorado, California, and Alaska. In planning these workshops, we found ourselves developing handouts that summarized our ideas and incorporated our experience working with previous groups of photography students. Little by little, these instructional materials grew into articles and, finally, into this series of books.

The contents of each book is truly an extension of our workshops. We've tried to convey the information in a simple, straightforward way, concentrating on techniques that really work. We try to keep jargon at a minimum, although a common vocabulary is necessary. Our approach has always been to encourage students to develop a personal vision before working on their technique, to get them to see with clarity and imagination before worrying about the complexities of their equipment.

Most of all, however, we want to help you discover your own form of expression in photography. This comes across most clearly in our workshops when we run the daily review session. Although a group of 12 to 15 people has been shooting in the same area and using the same basic equipment, each person finds a unique perspective. As we look at each other's work, we marvel to see how differently each of us sees the world.

One last point: people often ask whether it is possible to learn to be creative with a camera. Our experience has been that it certainly is. We used to wonder, when we looked at some photographer's first faltering shots during a workshop, whether there was any hope for improvement. Somehow there always was. For some participants, it came from our instructions and demonstrations. For others, it came from the critique sessions and the chance to see how others approached the same subjects. Still others grew by freeing themselves of the fears and insecurities that undermine our innermost ability to express ourselves.

That is what continues to be a source of pride and pleasure for us: the small ways in which we've helped other people find their own voice as photographers. We hope that the books in this series will do the same for you. Take them along as companions on your own photographic outings. Read them at your leisure, but refer back to them as you work in the field. They are the next best thing to being on a workshop with us.

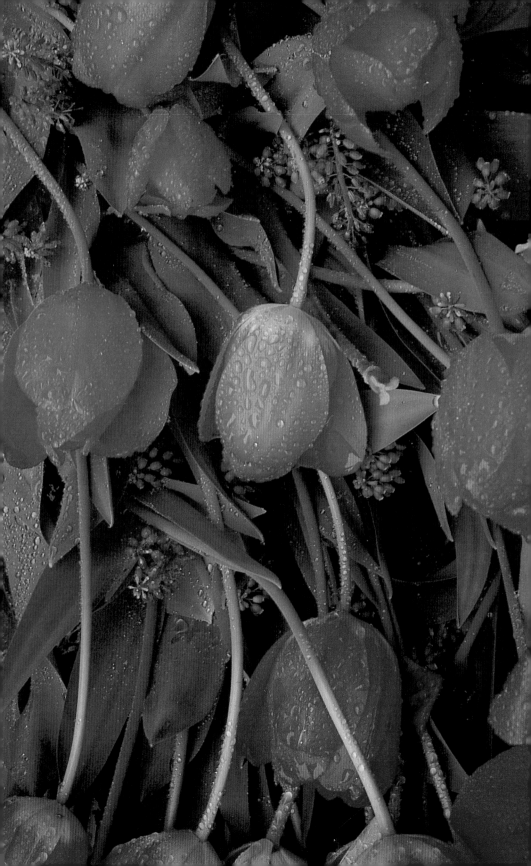

Imagine the Possibilities

Unlikely subjects, such as these predominantly red tulips bent by rain, can lead to strong photographs when you use your imagination. The yellow at the bottom of the tulips and the deep purple of the flowers peeking out among the green stems and leaves add effective splashes of color to this picture. To record this group of flowers at PepsiCo World Headquarters in New York, which many other photographers might pass by, I used my Olympus OM-4T, my Zuiko 35–70mm zoom lens, and Fujichrome Velvia. The exposure was f/11 for 1/8 sec. The result is a striking and unusual image.

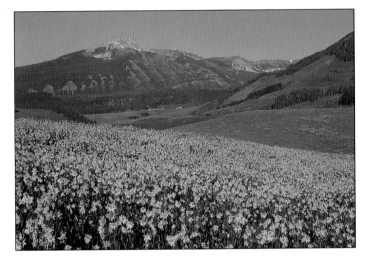

The extensive range of camera/lens combinations expands your visual possibilities. While photographing in Crested Butte, Colorado, I came across this mountain meadow filled with sunflowers. For this shot, I decided to use my Zuiko 50–250mm zoom lens on my Olympus OM-4T camera. The telescoping effect of the lens concentrated the bright yellow color of the flowers. Shooting Ektachrome 64 Professional EPX film, I exposed for 1/125 sec. at f/8.

What distinguishes great flower photographs from those that are merely good or competent? Why do some photographs make viewers take notice and leave a lasting impression while others swiftly fade from memory? These are the kinds of questions you'll need to answer for yourself in your goal to become a better flower photographer. Whatever unique qualities appeal to you and inspire you, keep in mind that all great flower photographs transform what is into what could be.

I photographed this blooming magnolia tree at The New York Botanical Garden during a surprise spring snowstorm. A slow shutter speed of 1/2 sec. transformed the swirling snowflakes into diagonal white streaks. The relatively monochromatic tonalities reveal the garden's tranquillity despite the unexpected snow. To record this scene, I used my Olympus OM-4T camera, my Zuiko 35–70mm telephoto lens, and I exposed Kodachrome 64 at f/11.

Put another way, great photographs don't simply record a subject; they accomplish two other ends as well. First, strong pictures extend the viewers' vision via an understanding and appreciation of the visible world by demonstrating new possibilities. Such images also make visible what isn't readily apparent to the eye—the unaided eye that isn't affected by photographic equipment or other optical devices. This includes the stopping of motion and supermagnification.

But, obviously, no camera, not even one of the new super-smart models, has the judgment needed to create truly outstanding flower images. Furthermore, no great photographs are simply the products of special equipment or film, or even professional-level technical skills. More than anything, strong flower pictures are the result of superior photographic vision.

THINK VISUALLY

To help you develop a more refined photographic vision, this chapter explains what it takes to see photographically and think visually. You must look at flowers as your camera and film will represent them, not as your eye sees them. This means understanding the difference between "taking" a photograph and "making" one. Taking pictures of flowers usually involves searching for a beautiful subject in the hope that one will reveal itself like a vision. When the "vision" appears, you frame the subject, snap the shutter, and keep your fingers crossed. You take photographs as an emotional response to something you see that appeals to you.

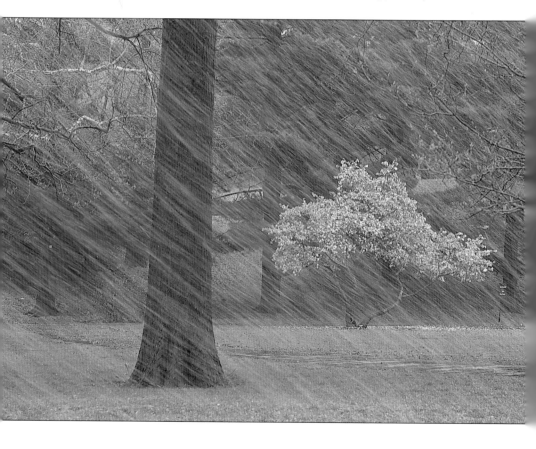

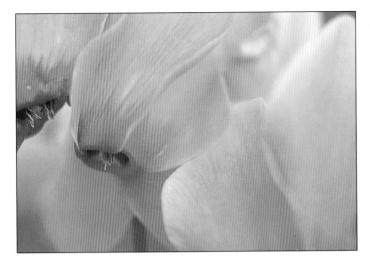

To capture the delicate shape and soft texture of the petals on these soft pink flowers, I decided to use my Zuiko 90mm macro lens on my Olympus OM-4T camera and a tripod. The repetition of shapes in the left-hand side of the image balances the out-of-focus petals on the right side. For this shot, I exposed Fujichrome 100 RD film for 1/30 sec. at f/8.

Making photographs is quite different. You search for subjects with a kind of radar that understands what is worth portraying and what isn't. Don't be concerned if your radar doesn't seem to work well. Although some people appear to come by it naturally, those who don't will develop it by applying the principles and ideas developed throughout this book. You look for subjects that are photogenic, not just beautiful; these subjects produce effective images, regardless of their condition. For example, a wilting flower can be photogenic. In addition, these subjects spark your imaginative powers and inspire you to translate their visual properties into powerful images on film. When you make photographs, you are selective. You choose subjects carefully, thoughtfully, and deliberately, tempering your emotional response with an analysis of the photographic possibilities.

Next, you must judge the raw materials critically. What do the flowers look like? What shapes, sizes, and colors are they? What are their textures like? What is the impact of the light on your subjects? How do you want to represent the relationship of the flowers to their setting? How do you want motion to affect the image? What elements need to be sharp? What elements are better off out of focus? What is the best exposure based on the subjects' colors and the available light?

Answering such questions helps you evaluate a subject so you can develop a clear mental picture of the image you want to create. Without this previsualized image, you'll have a hard time deciding which techniques and pieces of equipment to use. Remember, your camera, lenses, and film serve as tools that help you record what you imagined. You should always base your decisions about camera settings and other options on how you can best create the picture you saw in your mind's eye. To do this successfully, you must start by freeing your imagination when you look at flowers. You then need to learn how to use the tools and master the techniques that will serve your individualistic creative purpose.

KNOW YOUR PURPOSE

Previsualization is the key to creating masterful flower photographs. But getting a clear mental image of the photograph you want doesn't always come easily. For example, some people get so excited by the sight of a pretty flower that they quickly point their cameras and hope they'll get

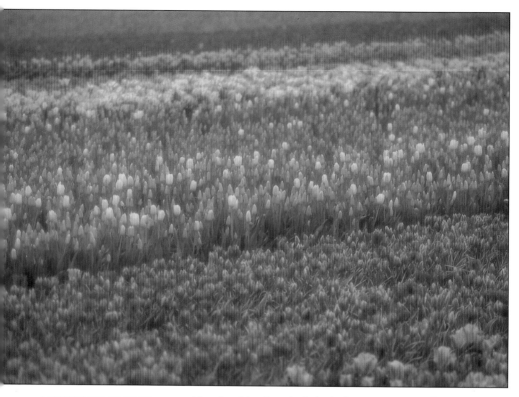

When I came across this field of tulips in a variety of colors in Lisse, Holland, I knew that an impressionistic interpretation would produce a pleasing image. To create this effect, I used a soft-focus filter on my Zuiko 300mm telephoto lens. This choice enabled me to emphasize the bands of color in the final image. Working with my Olympus OM-3 camera and Fujichrome 100 RD film, I exposed for 1/15 sec. at f/16.

something they like; they don't think about creating an effective image. Also, some amateur photographers believe that if they buy expensive equipment, their pictures will improve dramatically. But compelling flower photography requires thoughtful decision-making.

A good place to begin is by thinking about your purpose. After all, you must have a specific reason why you want to take this photograph—something that especially appeals to you about the subject. If you can articulate that, you'll have a better sense of your purpose.

A suggestion that many workshop students have found helpful is completing the statement "What I want to do is. . . ." Use this device whenever you have trouble defining your photographic purpose. Because this statement prompts you to focus your attention on what is most important to you, it helps you make decisions. You should complete the purpose statement as precisely as you can each and every time you are about to take a picture. Consider the pinpoint accuracy of the following examples: "What I want to do is document the structure and shape of this unusual desert flower"; "What I want to do is capture the delicate fuzz on this meadow flower"; and "What I want to do is show the mix of different colors and shapes in this field of flowers."

Your purpose may be straightforward documentary photography. You may be interested in recording a scene or panoramic vista in all its grandeur, capturing the charm of a group of flowers, or revealing the elegance of a single specimen in a tight closeup. On the other hand, your goal may be to create a more impressionistic image. For example, you may want to underscore the romantic mood of flowers after a drizzle to dramatize the beautiful backlight on a flower, or to create a powerful abstract image using the shapes and colors of flowers.

Every photographer's purpose concerning each image is valid and highly individual. At workshops, students shooting just several feet apart routinely produce completely different images of the same subject. This is primarily because they envision the inherent possibilities in a scene in their unique way.

Once your purpose is clear to you, you must ruthlessly and scrupulously follow one of our 10 commandments of flower photography: Less is more. Strip away whatever is unnecessary to your purpose in each frame, and include only those elements that will make an important contribution to the final outcome. At this point, you are ready to analyze the technical choices that will help you achieve the image you want to create.

The following list contains all 10 commandments that we recommend to workshop participants and visitors to the Center for Nature Photography.

- **Think for yourself**: Don't let fancy gadgets think for you.
- **Less is more**: Include only what is necessary in each frame; eliminate anything extraneous.
- **Light is everything**: Use every kind of light to its best advantage.
- **Be objective**: The camera sees everything; train your eye to do the same.
- **Imagine before you shoot**: The picture your camera takes can only be as good as the picture your mind creates.
- **Make it simple**: As a photographer, your task is to make order out of chaos.
- **Beauty is made, not found**: Ordinary objects seen by a sensitive eye are transformed into extraordinary images.
- **Master your equipment**: Understand your gear, so that it serves your eye's and mind's intentions.
- **Never say "done"**: There is always one more way to shoot the picture.
- **Express yourself**: The joy of photography comes from the ability to project a unique vision that you can share with others.

In order to isolate a single coreopsis from its surroundings at Anza Borego State Park in Death Valley, California, I needed to use a powerful telephoto lens. I knew that my Zuiko 500mm mirror lens would enable me to create the look I wanted for these flowers, which are also called desert gold. I also relied on my Olympus OM-3 here. The exposure was 1/250 sec. at f/8 on Fujichrome 100 RD film. The resulting picture boasts a compelling composition that draws the viewer's eye to the single stem.

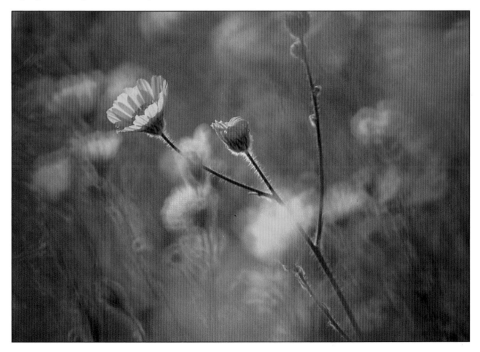

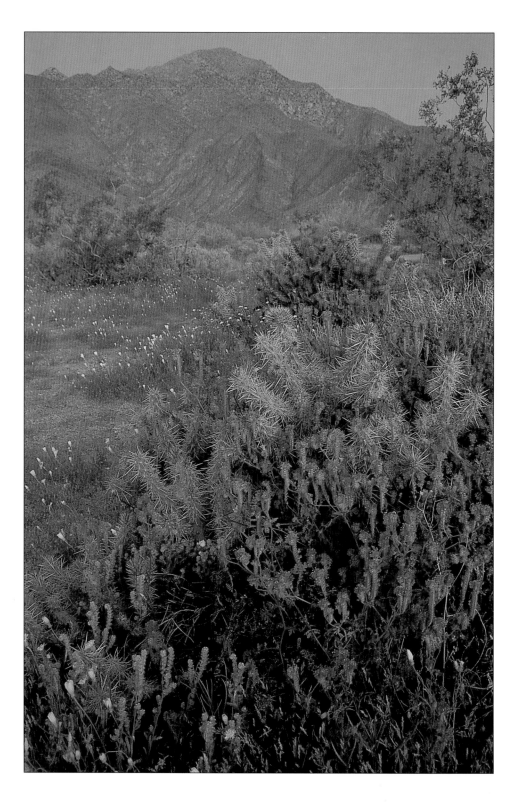

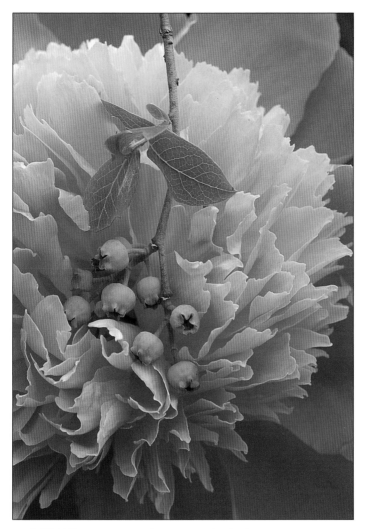

To integrate flowers in the foreground with their landscape, use a wide-angle lens and a low perspective. Shooting in California, I captured these verbena at Anza Borego State Park with my Zuiko 35–70mm zoom lens set at 35mm. Working with my Olympus OM-4T, I exposed Fujichrome Velvia for 1/2 sec. at f/16.

I made this shot because I wanted to reveal the delicate contrast of the green berries and leaves against a pink peony in Bar Harbor, Maine. For this quiet photograph, I used my Olympus OM-4T and my Zuiko 35mm lens; I exposed Fujichrome 100 RD film for 1/60 sec. at f/5.6.

UNDERSTAND THE TECHNICAL CHOICES

Vision and technique must work hand in hand if you hope to make magnificent flower photographs. Neither alone can do the trick. Your success in creating the flower photograph you have in mind is determined, in part, by how well you understand the technical variables that can help you achieve it.

With today's "smart," sophisticated cameras, photographers must often weigh the tradeoffs between convenience and control. In general, flower photography depends more on the photographer's aesthetic vision and less on quick responses to changing conditions. Serving that vision often requires manual manipulation of the technical variables. In fact, some photographs can't be made without this control. As a result, if you have an "auto-everything" camera, you must override its multitude of automatic features and options in order to determine what your final images will look like.

The following camera features and accessories point to some of the differences between how the human eye sees and how the camera sees.

As a flower photographer, you must give these careful thought in your effort to transform as well as to record reality.

■ **Shutter speed.** The shutter speed controls two variables: motion and light intake. The slower the shutter speed, the greater the effects of motion and the larger the amount of light entering the camera—all other variables being equal. For example, a relatively slow shutter speed of 1/30 sec. or 1/60 sec. allows more light to enter the lens than a faster shutter speed of 1/125 sec. or 1/250 sec. does.

By changing the shutter speed, you can show your subject in ways that no human eye can glimpse. Very fast shutter speeds can record a micro-instant, freezing motion completely. This capability is especially useful when a breeze is tossing your floral subject around and when you want to minimize camera shake when shooting handheld. Conversely, very slow shutter speeds can depict the movement of flowers as a blur or a streak, thereby letting you experiment with impressionistic images that you can't fully predict. Before you set your shutter speed, then, you need to think about the amount of movement you are likely to encounter.

You also have to consider how much light you're working with. Since flower photography is generally done outdoors using natural, or available, light, you should learn to analyze the direction and intensity of this type of light. This will help you choose the best combination of camera settings—both shutter speed and aperture—for the light intake required to render both radiant and subtle colors most effectively (see Chapter 2 for a full exploration of light in flower photography).

■ **Aperture.** A camera's f-stops dictate the size of the lens opening, or aperture, which in turn affects two variables: light intake and depth of field. Controlling depth of field opens the door to untold creative possibilities and enables you to experience firsthand one of the chief differences between the ways the human eye sees and the camera sees. The

Shooting in New York, I chose a telephoto lens in order to narrow the depth of field in this shot. I wanted the background behind the aster to blur into a delicate wash of color. After mounting my Zuiko 180mm telephoto lens on my Olympus OM-4T, I exposed Fujichrome 50 RF film for 1/250 sec. at f/4.

Filling the frame with this tiny backlit flower required a macro lens plus an extension tube and slight underexposure. Shooting in California's Anza Borego State Park, I chose my Olympus OM-4T and my Zuiko 90mm macro lens fitted with a 25mm extension tube. The exposure was 1/60 sec. at f/5.6 on Fujichrome 100 RD film.

(Overleaf) The use of a small aperture ensured that every tulip in this telephoto shot, made at The New York Botanical Garden, appears sharp. To capture the brilliant reds and yellows, I mounted my Zuiko 180mm telephoto lens on my Olympus OM-3. Shooting Fujichrome 100 RD film, I exposed at f/11 for 1/250 sec.

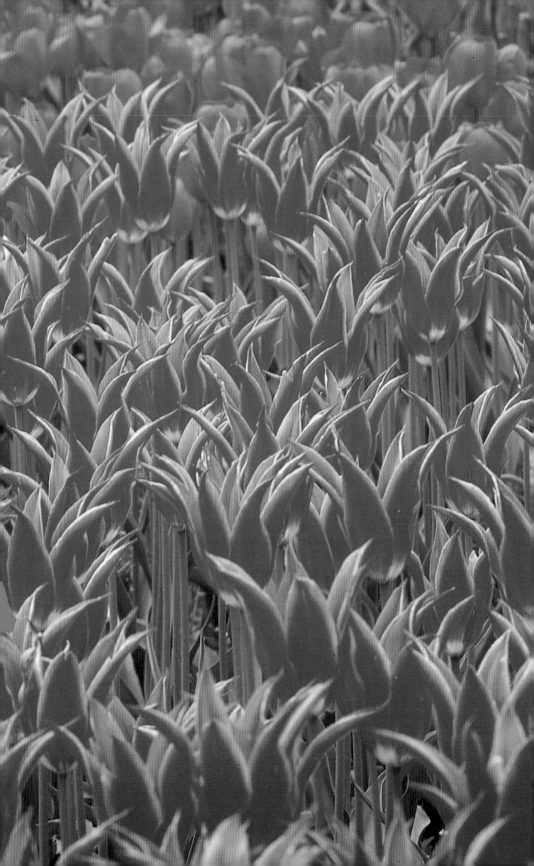

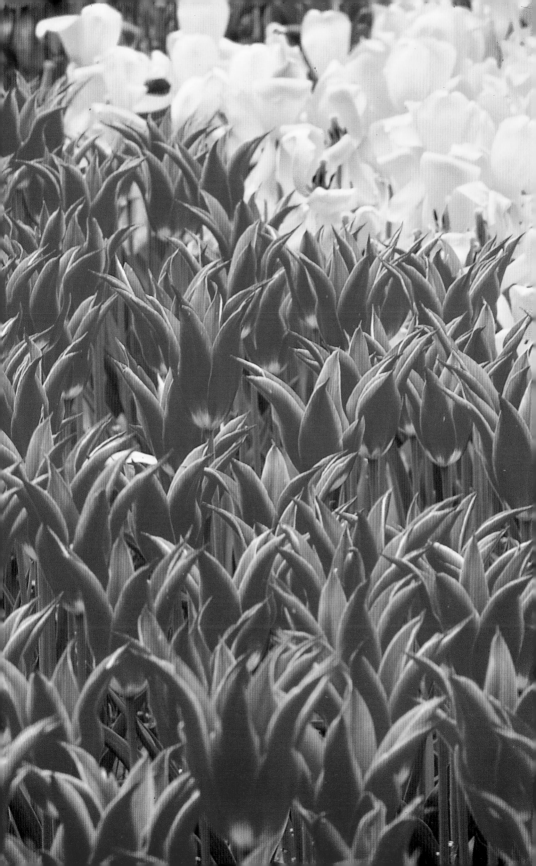

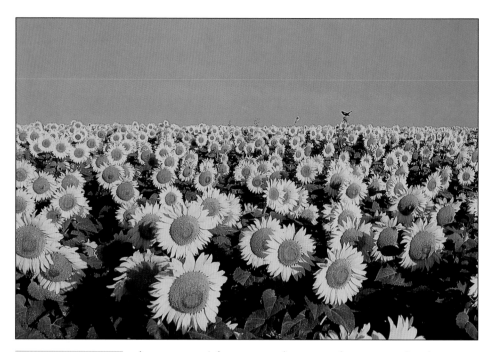

human eye can't focus on two distances at the same time, but the camera permits you to determine the degree of sharpness in an image from foreground to background.

If you think about how sharp or blurred you want the background to be, your choice of f-stop will serve your imagination. The smallest aperture setting maximizes sharpness throughout the frame, producing the greatest depth of field. A large aperture setting, on the other hand, limits depth of field, thereby letting you select an area of sharpness, usually in the foreground, which in turn renders the rest of the image out of focus.

■ **Focus.** Through the viewfinder of most single-lens-reflex (SLR) 35mm cameras, you can see precisely what parts of your subjects are in focus. But all cameras have a mechanism for bringing a point in the viewfinder into the sharpest focus, whether manually or automatically. Having manual control of the focus point is an important advantage in flower photography. Obviously, an automatic-focus camera can't know what you want in sharpest focus; this autofocus feature is particularly problematic if you don't want everything you see in the viewfinder sharp (see Chapter 3).

■ **Lenses.** The human eye sees the world from the same perspective all the time. But a camera that has interchangeable or zoom lenses lets you change perspective easily. A telephoto lens, for example, narrows your field of vision and brings distant subjects closer. This capability enables you to isolate a single flower in a field, as well as to compress the space between subjects that are near and far. Conversely, a wide-angle lens broadens your perspective, even at close range, and stretches the space between foreground and background subjects. Keep in mind, however, that some people consider this effect to be a distortion. Still other lenses permit you to shoot extreme closeups. If you aren't familiar with the effects of various lenses, experiment with someone else's gear. Then when you are ready to shoot, choose the lens that will best enable you to achieve your previsualized image.

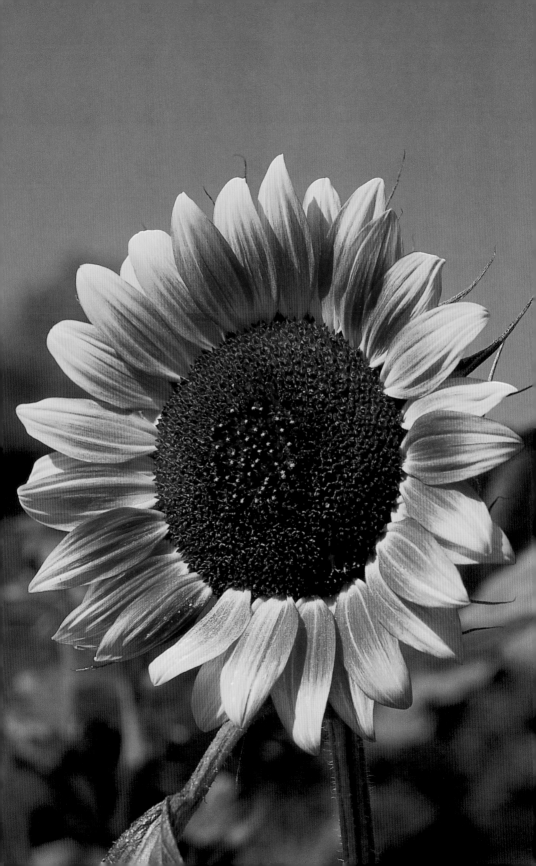

LOOK BEFORE YOU SHOOT

After you've thought very hard about the kind of image you want, both aesthetically and technically, you still have to do the hard work of actually creating it. This process requires great concentration, determination, and patience for all types of photography, but it is especially true about flower photography. You must work slowly and methodically and pay careful attention to the most minute detail.

The following is a checklist of steps you should take before you begin photographing a floral subject.

■ **Study the subject thoroughly.** Move toward it, around it, and away from it. Look at it from above and below. Think about how changing the camera position just a little can either result in a much stronger composition or make the image more interesting. Then select the most promising viewpoint for the result you want.

■ **Maximize strengths, and minimize weaknesses.** Identify what is most beautiful about your subject, and make the most of it in your composition.

The lovely light that bathes one day lily at The New York Botanical Garden is dramatized by its contrast to the shadowy surroundings. To capture this striking image, I used my Olympus OM-4T and my Zuiko 50mm lens, and exposed Fujichrome 100 RD film for 1/125 sec. at f/2.8.

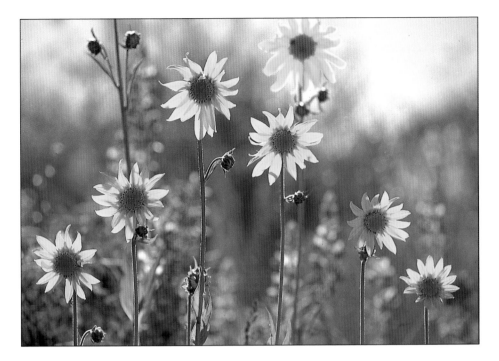

Observe the flow of lines, shapes, colors, and/or textures, and play to the strongest elements. Notice the patterns of light and shadow, particularly those in the background, and use them to greatest advantage. When you recognize distracting aspects of the surroundings, find ways to disguise or eliminate them.

■ **Edit in the camera.** Look across the entire plane of the film frame, to the edges and into the corners. Photographers tend to see what they wish to see, but the camera sees everything. As a result, you must train your eye to be just as objective. Include only what you want in your image, and eliminate whatever is unimportant by moving closer, changing perspective slightly, using a different lens, or throwing unwanted elements out of focus.

■ **Shoot a lot of photographs.** No matter how gorgeous your masterpiece looks through the viewfinder, you can't be absolutely sure how your floral subject will really look until you've developed the film. Shoot extra frames if this will increase the odds of getting at least one special image. This process, which is called bracketing, involves shooting pictures whose exposure settings differ slightly from that suggested by an accurate meter reading.

As extravagant as bracketing may sound, it is worth the extra time, energy, and expense: this safeguard greatly increases your chances of achieving exactly what you want. Furthermore, since flowers are often here today and gone tomorrow, the opportunity to return to photograph them under similar conditions is rare.

■ **Never say done.** The best photographs are often created simply by trying over and over again. Professional photographers know this, and you can learn from their example. Keep working to improve a specific image, and don't give up until you have tried every possibility you can think of.

A very low perspective enhances the effect of backlighting on these sunflowers, which I came across in Crested Butte, Colorado, and improves the composition. In order to shoot successfully from this unusual angle, I used my Olympus IS-3 camera, its 300mm telephoto lens, and Fujichrome 100 RD film. I exposed the scene for 1/250 sec. at f/5.6.

EXTEND YOUR IMAGINATION

There is no end to the photographic possibilities you can explore with an unfettered, well-nourished imagination. Begin to loosen up your creative potential by studying flower images made by master painters and photographers. Notice that in general they don't try to create "flower portraits." (Many photographers' early efforts—ours included—amount to little more than mug shots.) They look at flowers with a fresh eye and avoid visual clichés.

To break out of your routine, you need to change the way you ordinarily look at or photograph flowers. If you tend to shoot from above, get down on the ground and look at flowers from below. If you tend to shoot from safe distances, force yourself to move closer to potential subjects. If you tend to shoot in the middle of the day, see how different the world looks at dawn or dusk. If you tend to shoot in sunshine, go out when it is drizzling and see the impact a change in the weather can have on your images.

Once you've tried all of these approaches and you are ready for more, consider experimenting with lenses, filters, electronic flash, and a variety of camera settings. If you tend to use a 50mm standard lens, experiment with other lenses, such as a telephoto or a wide-angle lens. Give yourself assignments that push your creative limits. For example, Ernst Haas often went on a photographic outing with just one lens to see how many different types of images he could create.

Our workshop participants respond well to an assignment that calls for them to start by photographing one flower, then to move on to two flowers, then three flowers, and so on. You should try this exercise. Each time you add another flower to the composition, you'll find yourself stretching your imagination in order to come up with the best photographic solution. By confronting new challenges, you'll extend the boundaries of your imagination. Undoubtedly, you'll discover images that you never thought possible.

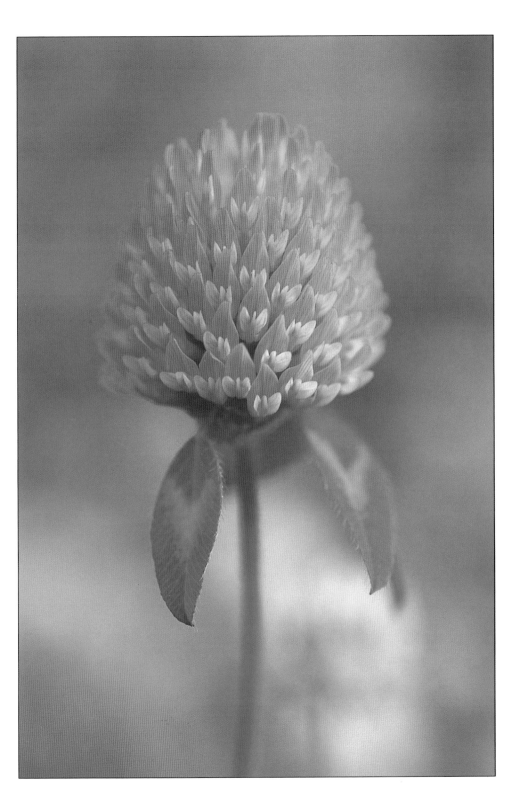

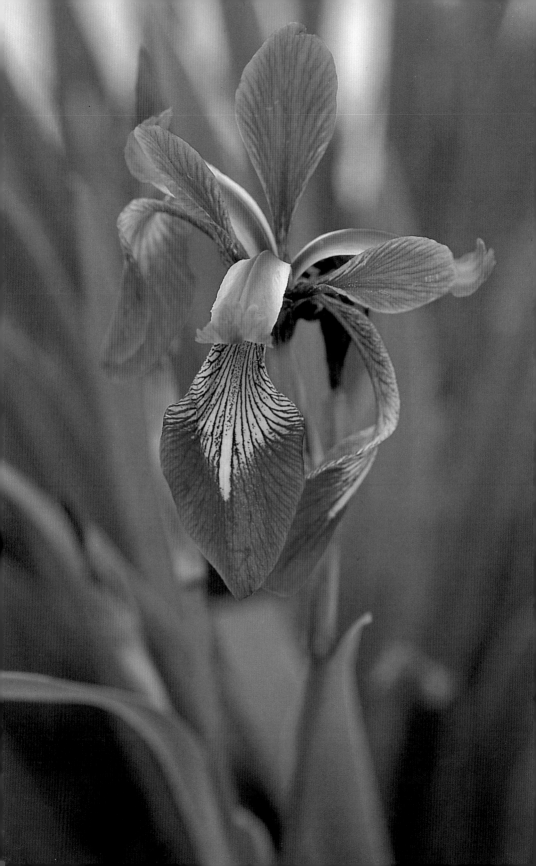

CHAPTER 2

Understanding Natural Light

To effectively capture this iris in natural light, I chose Fujichrome Velvia because it records greens so well. Shooting at the Morton Arboretum in Illinois, I mounted my Olympus OM-4T and Zuiko 90mm macro lens on a tripod and exposed for 1/30 sec. at f/5.6.

A brief shaft of light spotlights this orchid, bringing out its vibrant color and intricate form. I photographed this single bloom at The New York Botanical Garden with my Olympus OM-4T and Zuiko 90mm macro lens, which I'd mounted on a tripod because I was shooting a slow film. The exposure was 1/15 sec. at f/16 on Kodachrome 25.

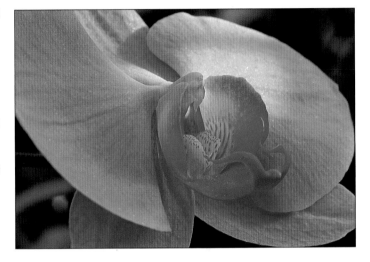

Light is the raw material that the photographic process transforms into lasting images. Whenever you photograph, you engage in a subtle alchemy, shaping that raw material and filtering it through your imagination. In nature photography, this process is complicated and enriched by the interplay between the photographer and the light at hand. Unlike the studio photographer, the nature photographer must submit to the discipline of responding to—rather than creating—the elemental resource of light.

Bright midday sunshine bounces off nearby flowers and foliage to fully illuminate the underside of this tulip. I made this shot in Holland with my Olympus OM-4T and Zuiko 300mm lens fitted with a 39mm extension tube, all of which I'd mounted on a tripod. Shooting Fujichrome 100 RD film, I exposed at f/4 for 1/250 sec.

What this means is that you must sensitize yourself to the possibilities in every kind of lighting. You must find magic not just in the dramatic light of a sunset, but also in the softness of mist and in the cool shadows of shade. You must open yourself to emotional responses triggered by various kinds of illumination and begin to see the creative possibilities in each. Most of all, you must become aware of how each kind of light alters the appearance of flowers and other subjects in nature.

After delving into your inner reactions, you must move in the opposite direction, becoming an objective observer of the scene and analyzing the available light in detail. This is the crucial step between vision and technique because without it, you won't be able to make the necessary decisions to turn the image in your mind's eye into a finished product. This chapter will help you understand how to analyze natural light so that you can use your equipment as a tool in the making of your inner image.

LOOKING FOR BEAUTY IN LIGHT

What gives great flower pictures their power is how well they capture the qualities of light. For photographers, each flower isn't just a rose or a tulip, but a bundle of light with distinct, discernible qualities. Once you recognize the beauty in light, you can maximize its potential whether you're photographing in your backyard or in some far-off exotic land.

Your search for special qualities of natural light that bring out the best in flowers begins by your experiencing times of day or kinds of weather that you've avoided or neglected in your photography. Early-morning or late-afternoon sunlight is warmer in color, softer in intensity, and more dramatic than midday light. That is why professional nature and flower photographers think nothing of getting up before dawn to capture this wonderful low-angled light: the soft pink rays of dawn and the intense glow of sunset. Low-angled light can filter through a flower's petals either from behind or from the side, making the flower glisten and revealing its interior forms and structures.

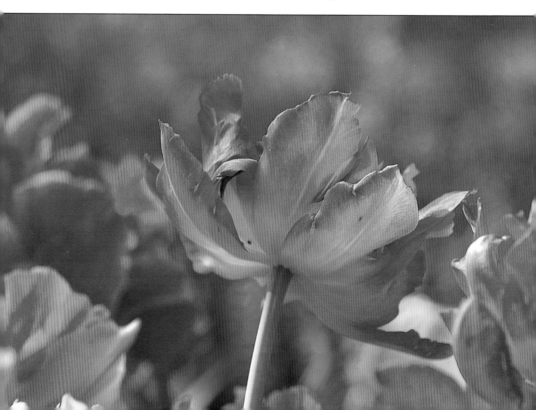

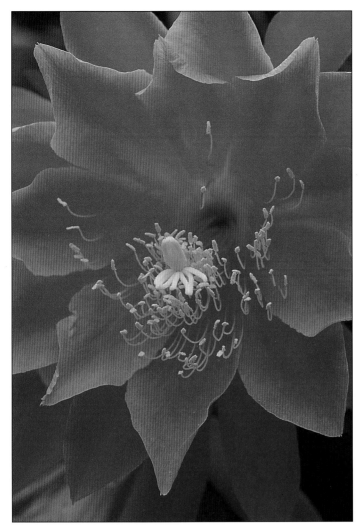

Too often, flower-photography buffs overlook overcast or misty days and areas of shades. In fact, however, these diffused, uniform-light conditions enhance textures and bring out the rich colors of flowers without glare, obtrusive shadows, or distracting hot spots. Take advantage of the muted tones of a cloudy afternoon or the dramatic gloom of a summer storm. Shooting after a drizzle is a favorite approach of photographers who love the look of dewdrops on flowers.

The effect of light on flowers often changes quite noticeably as you move around them. Find the most beautiful light by looking at flowers from below, from above, and from one side and then the other. Notice how each perspective alters the color or luminosity of the flowers. And try to set brightly illuminated flowers against a dark background or shadow in order to create a theatrical "spotlight" effect.

There is a beauty in light, no matter the time of day, the season, or the weather. Once you recognize it, let your newly found sensitivity and understanding guide your photography. You'll find yourself going out to shoot simply because the light has great potential. By doing this, you'll

learn to make the most of the available light, adjusting your technique and perspective to create the image in your mind's eye. Keep in mind that no type of light is bad light. You can show every kind of light to its best advantage. This, however, requires a technical analysis of the light's three main features: direction, color, and intensity.

DIRECTION OF LIGHT

More than any other factor, the direction of light affects the vitality of flower photographs. To determine the direction of daylight, consider the relation of three components: the light source itself, the floral subject, and the camera. In the typical arrangement depicted in the schematics packed with film, the camera is between the light source and the subject. Light falls frontally on the subject, from either overhead or over the photographer's shoulder. Such frontlighting, which is also known as toplighting, enables you to shoot for maximum clarity with a small aperture. However, unless you compensate for strong frontal light, colors tend to wash out. To saturate colors in these shooting situations, you must underexpose by up to 1¹/₂ ƒ-stops.

But for flower photographers, light from two other directions, the back and the side, offers better opportunities for spectacular light effects than frontlighting does. With backlighting, the available-light source is behind the flower, and the sun's rays pass through it toward the camera. The result is a translucent look that resembles stained glass. Backlighting makes flowers with rich colors shimmer like jewels and transforms even ordinary flowers by bathing them in an ethereal halo. And if a flower has an interesting shape, backlighting can highlight it as a silhouette.

Many photographers have been warned never to shoot toward the sun because this approach makes achieving proper exposure tricky. In fact, however, the technique for shooting with backlighting isn't hard to master and is well worth adding to your repertoire. Here is what to do. Take either a closeup meter reading at a distance of 6 to 12 inches from your subject or a spot-meter reading of the flower. Use a handheld spot meter or the spot-meter setting on your camera's built-in meter. These are very narrow meter readings, pinpointing a 1-to-3-degree area.

Next, bracket three frames at half-stop intervals toward overexposure. You can overexpose a subject two ways: by using a slower shutter speed, or by opening the aperture to the next ƒ-stop. For example, if the meter

When photographing this cactus lily at The New York Botanical Garden, I realized that dictating the direction of the light hitting the flower would determine the appeal of the final image. I placed an Olympus T8 ring flash in front of the lily and an Olympus T20 behind it in order to reveal its inner structure's. Working with my Olympus OM-4T and Zuiko 80mm macro lens mounted on a tripod, I exposed Fujichrome 100 RD film for 1/60 sec. at f/32.

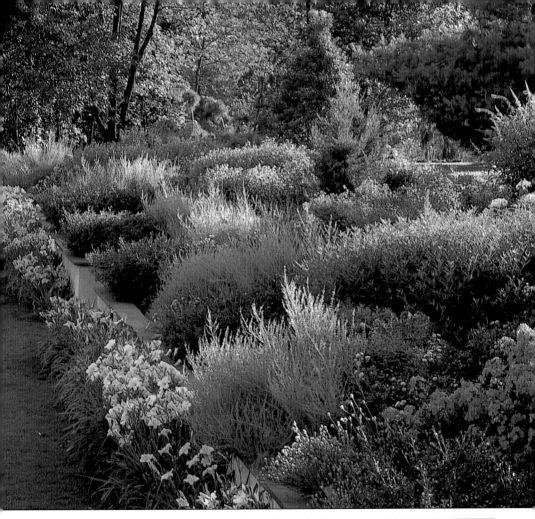

reading is 1/60 sec. at *f*/5.6, overexpose either by reducing the shutter speed to 1/30 sec. or by changing the aperture to *f*/4. If you're working with an automatic-exposure camera, bracket by turning the exposure-compensation dial to +1, locking in your closeup meter reading, and then moving back in order to recompose the image.

When you find yourself in a backlighting situation, remember that you must minimize flare, the unwanted light that reflects into the camera lens, by shielding your lens. Flare reduces contrast and color saturation in your photographs. If your lens shade doesn't do the job, protect your lens with something else, a piece of cardboard or a baseball cap perhaps. Simply remember to look through the viewfinder to make sure that your improvised shade doesn't show in the picture frame.

With sidelighting, the light source is at about a 90-degree angle to the side of the camera, with the flower at the vertex of the imagined angle. Sidelighting produces a theatrical effect called "chiaroscuro," the half-light, half-dark modeling associated with the paintings of Caravaggio and Rembrandt. The play of light and shadows created by sidelighting enriches colors and effects the illusion of depth by revealing a flower's surface texture, line, and form. The light/shadow combination also produces a modified halo effect; here, a luminous ring of light surrounds all or part of the subject. Keep in mind, though, that in shooting

Low-angled backlighting casts shadows on the border of perennials at PepsiCo World Head-quarters in New York. As a result, the texture of the plants is enhanced. For this shot, I used my Olympus OM-3, my Zuiko 100mm lens, and a tripod. I then exposed at *f*/16 for 1/15 sec. on Fujichrome 100 RD film.

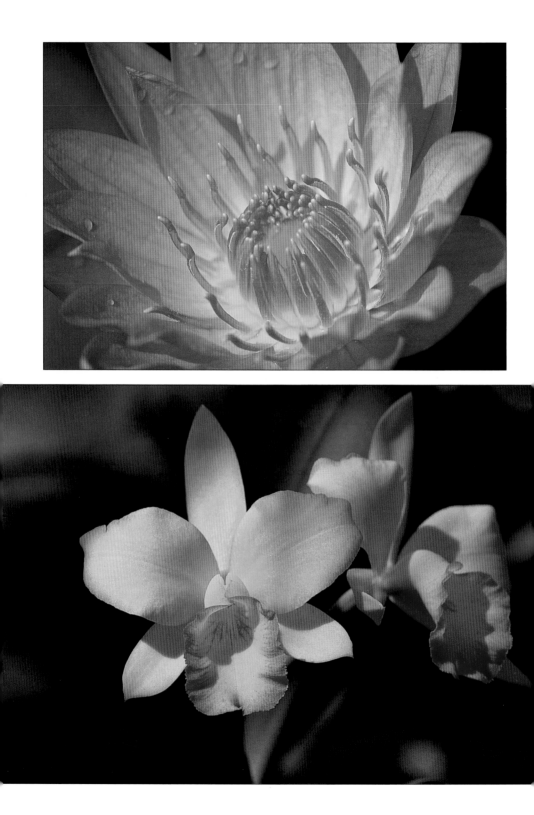

situations characterized by very contrasty light, the shadow side of the subject may be much darker than the bright side. To reduce the contrast, add light to the shadow side by using either a reflector or fill-in flash.

Strong photographs that feature sidelighting and backlighting effects are easiest to accomplish in the late afternoon and early morning. At these two times of day, the sun's rays are low. As a result, you won't have to lie on the ground below the level of the flowers to take advantage of directional light. In addition, the color of low-angled light is warmer and softer than the blue-white brightness of midday illumination. Finally, you can control the direction of light to some extent by moving around and changing your perspective.

COLOR OF LIGHT

While most photographers are sensitive to the color of flowers, they don't always pay attention to the color of light. This is surprising because a change in the color of light can bring new energy and excitement to your flower photographs. The color of direct sunlight varies with the time of day. White light—that is, light with no visible color—consists of

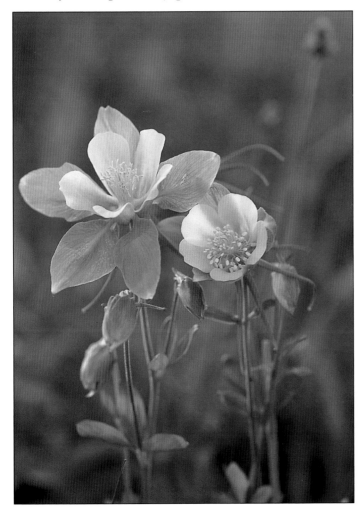

Strong, low-angled front-lighting produces a sunset glow on this water lily at Longwood Gardens in Pennsylvania. I made this dramatic portrait with my Olympus OM-4T, my Zuiko 180mm telephoto lens fitted with a 25mm extension tube, a tripod, and Fujichrome 100 RD film. The exposure was 1/60 sec. at f/11.

Sidelighting coming through a window creates shadows that reveal the shape of this Brazilian orchid; it also enhances the flower's golden color. Shooting in a Bronx, New York, greenhouse, I mounted my Olympus OM-4T and Zuiko 90mm macro lens on a tripod. Here, I exposed Fujichrome 100 RD film for 1/250 sec. at f/5.6.

The cool, blue light of dawn enhances the color of this mountain columbine, which I came across in Colorado. Working with my Olympus OM-4T and Zuiko 50mm macro lens secured on a tripod, I exposed Fujichrome Velvia for 1/15 sec. at f/5.6.

(Overleaf) The gray color of fog and mist softly illuminates this bulb field. I made this shot in Holland with my Olympus OM-3 and Zuiko 50–250mm lens mounted on a tripod. The exposure was 1/60 sec. at f/8 on Fujichrome 100 RD film.

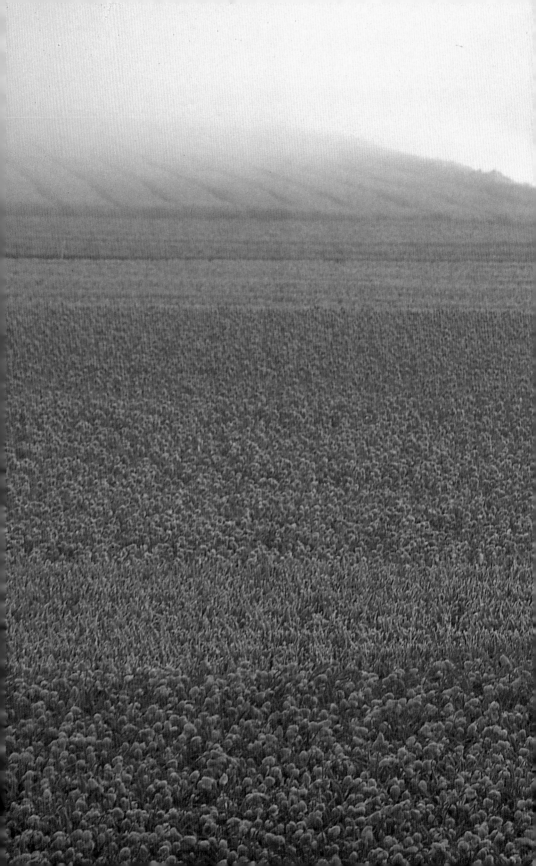

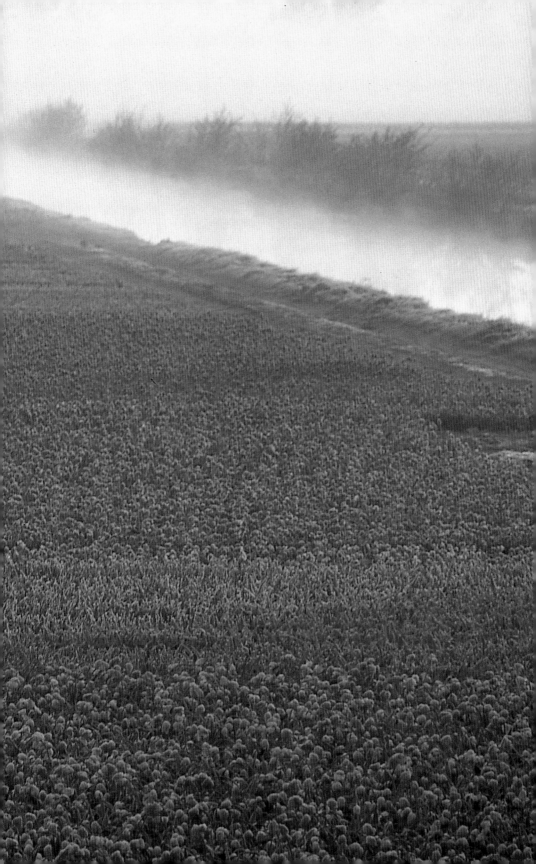

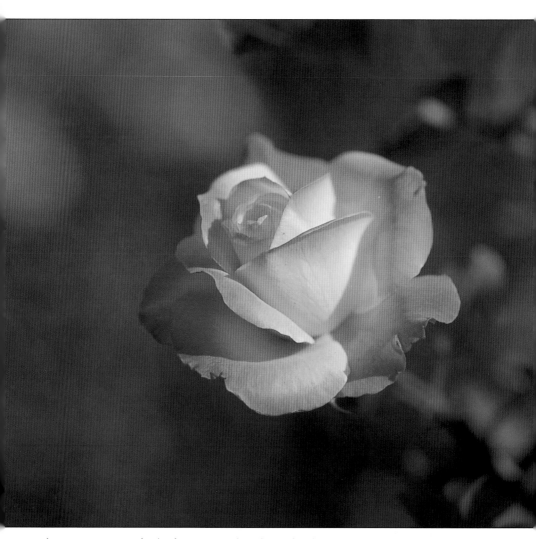

the entire spectrum of color frequencies when they're fused into one. But as the sun's rays bend at different angles throughout the day and over the cycle of seasons, various parts of the color spectrum gain prominence.

For example, first morning light begins as a flat gray that shifts to a delicate blue. As the sun emerges, mauves, warm pinks, and pale yellows emerge. The bright blue sky of midday gives a cool bluish cast to a scene. Then as the sun arcs down toward the horizon, fiery oranges, golds, and reds bathe the earth. And at twilight, blues, violets, and greens may dominate. As the autumn sun gets lower, its rays become more golden, while the rising position of the sun as spring turns into summer makes the light whiter.

Be aware that the color of direct light is also affected by any overhead foliage and handcrafted canopies it may pass through before striking flowers. Such atmospheric factors as weather, pollution, and airborne particles can also alter the illumination. Furthermore, in addition to noticing the color of direct sunlight when you prepare to shoot, you should pay attention to the effects of any reflected illumination that bounces off

Sunset bathes this rose, photographed at The New York Botanical Garden, with a warm, golden tone. After mounting my Olympus OM-4T and Zuiko 180mm telephoto lens fitted with a 14mm extension tube on a tripod, I determined exposure: 1/125 sec. at f/4 on Fujichrome 50 RF film.

The surrounding foliage reflects a soft green color onto this California poppy. For this floral portrait, I secured my Olympus OM-3 and Zuiko 90mm macro lens on a tripod and exposed Fujichrome Velvia at f/5.6 for 1/15 sec.

your subject's surroundings. You may find that flowers may take on some of the green of a forest, the blue of a lake or the sky, or the hues of nearby houses and buildings.

Each of these variations changes the appearance of color of a given floral subject, for better or worse. For instance, the light of dawn may enhance the color of a pink flower, while the light reflected from a stone building may give the same flower a gray cast. Being cognizant of such potential shifts may inspire you to plan to be in the right place at the right time. Alternatively, it may remind you to use a color correction (CC) filter; an 81A sepia filter warms blue tones, and an 82 cyan blue filter cools down reds and yellows. When shooting in mountainous areas, use a colorless ultraviolet (UV) filter to cut through blue haze.

Being objective about the colors you see is an important step toward achieving the colors you want in your flower photographs. Another step is deciding whether you want to reproduce or manipulate the colors you see with filters or electronic flash (see pages 77, 81, and 82). But the most critical step in rendering colors as you want them is understanding how to work with the intensity of the available light.

LIGHT INTENSITY

The intensity of light ranges from the very brilliant light of a cloudless, sunny day to the dim light that characterizes the period before a thunderstorm. It also includes every type of illumination in between, such as dusk and sunset. Conventional wisdom recommends photographing on bright, sunny days for the best results. But for nature and flower photographers, every degree of light intensity offers special opportunities and challenges.

The brightest light occurs when the sun is overhead and casts deep, dark shadows. Flowers can appear quite sharp when recorded on film in this high-intensity light. This is because you can use both a small aperture and a fast shutter speed to create images here. You can increase apparent sharpness even more by photographing a brightly illuminated flower against a dark backdrop. When you spotlight a flower this way, it can appear sharper than it may actually be. With such high-contrast illumination, the light differential fools the human eye into seeing the line of demarcation or the edge of the image in a more defined way than it would in a low-contrast situation.

A sudden change in light intensity, from strong sunshine to dull, overcast light, dramatically altered this Colorado scene. While the bright illumination enhances the setting of this patch of sage and Indian paintbrush (right), the less intense light saturates the soft reds and greens (opposite page). For both of these shots, I mounted my Olympus OM-4T and Zuiko 35mm lens on a tripod, and then exposed for 1/30 sec. at f/16 on Fujichrome 100 RD film.

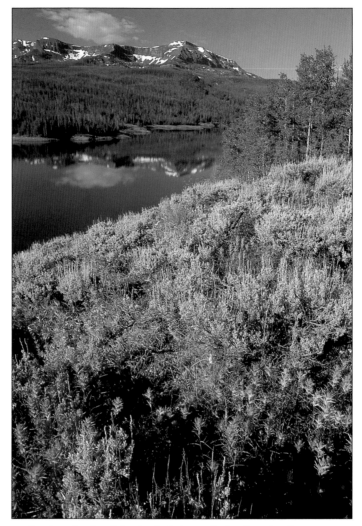

On the other hand, bright daylight can be harsh and unflattering to flowers: it can flatten textures and bleach colors. Another problem is that bright spots and glare can mar your image. And the great disparity between the bright parts and the dark, shadowy areas in a floral scene shot at midday makes it hard to meter accurately. To use high-intensity light to its best advantage, keep the following suggestions in mind.

■ **Maximize color saturation** by metering the highlights in a scene. If you meter the highlights or bright areas, the reading will tend toward underexposure, thereby saturating colors throughout the image. With automatic cameras, take a closeup meter reading and lock it in before recomposing. If you can, bracket one or two *f*-stops toward underexposure.

■ **Make the most of high-contrast situations** by framing brightly colored flowers in full sun against a dark, shadowy backdrop. Be sure to move around until you find a perspective that eliminates bright spots in the background.

■ **Reduce glare and unwanted reflections** with a polarizing filter and lens shade. A polarizing filter, or polarizer, mounts on the camera lens

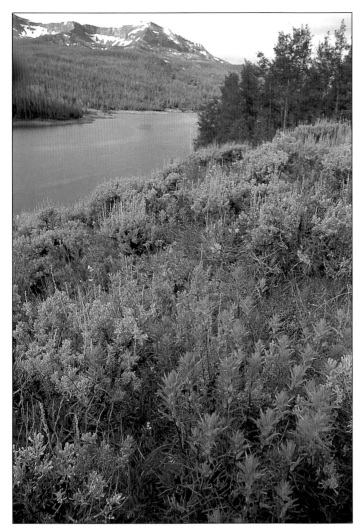

and absorbs polarized light in varying degrees as it is rotated. This useful filter removes glare and reflections from surfaces, darkens the sky, and lightens clouds.

Less intense types of light include the softer, more uniform light of an overcast day, the delicate light that filters through the dense canopy of foliage in a woods, and the velvety light found in the shadows of an otherwise brightly illuminated scene. Although many amateur photographers tend to avoid such diffused light, it offers marvelous possibilities for flower picture-taking. And it isn't just a matter of making the best of a bad situation. Diffused light is relatively easy to work with, simplifies metering, and saturates colors without underexposing.

Make the most of shooting in diffused light by bringing out the subtler aspects of flowers: pastel colors, fuzzy textures, and abstract forms. With its softened contrast, this gentle light is ideal for closeups and flower portraits because it enhances both delicate and strong colors and minimizes the distraction of shadows and glare. However, if you're photographing in deep shade, you need to check whether bright spots, glare,

The rays of the early-morning sun cast delicate side-lighting on this California desert mallow. I used my Olympus OM-4T, my Zuiko 90mm macro lens, and a tripod. The exposure was 1/60 sec. at f/4 on Fujichrome 100 RD film.

The uniform illumination of an overcast, rainy day reduces the contrast between the white loose-strife and the dark green foliage surrounding them. Naturally, this even lighting made determining exposure relatively easy. Here, I used my Olympus OM-4T, my Zuiko 35mm lens, and a tripod, and exposed Ektachrome 100 Plus EPP film for 1/15 sec. at f/11.

or reflections in the background are spoiling your composition. If possible, find a perspective that incorporates any bright background light as a radiant halo around the flowers. And to avoid the blank space of an uninteresting, overcast sky behind a floral subject, just tip the camera down or concentrate on tight closeups.

The monochromatic light that is present in rainy, misty, and foggy conditions is still less intense but wonderfully evocative. It enables you to create a mood rarely seen in flower photographs, which is all the more alluring because few amateurs utilize it. Flowers can be particularly photogenic in the dim light after a rainstorm. A drizzle can transform a scene into a veritable fairyland. Greenery glistens, flowers look fresh and inviting with raindrops on their petals, and an aura of mystery and romance envelopes everything. Looking at ordinary subjects at such extraordinary moments gives bad-weather flower photographs their dramatic impact.

Shooting in light of a very low intensity makes achieving sharpness more difficult. A tripod is a must in these situations. Furthermore, if it is

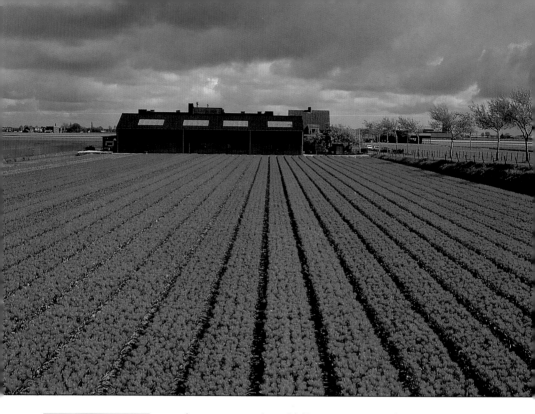

The strong, low light of
sunset illuminates this field
of tulips as dark thunder-
clouds gather on the hori-
zon. This kind of lighting
condition shows the dra-
matic contrast that typically
occurs before and after
storms. I made this shot
in Holland with my Olym-
pus OM-4T, my Zuiko
35–70mm zoom lens, and
a tripod. The exposure was
1/30 sec. at f/16 on
Kodachrome 25.

windy, you may need to add illumination via an electronic flash or a
reflector to prevent the blur of movement (see page 77, 82, and 83).

Take some time to appreciate the distinct qualities that each level of
light intensity offers, and try to turn those variations to advantage. And,
remember, the most important skill you need to learn is being able to
adapt to shooting in every kind of light. You may not always be able to
return for another try at photographing the flowers that caught your
fancy, and the flowers themselves will never be exactly the same.

EXPOSURE

With the advent of the new "smart" cameras, achieving proper exposure
isn't the chore it once was. In many shooting situations, automatic expo-
sure is quite adequate. In flower photography, the best test of proper
exposure is determining if the colors in the final images are fully saturated.

However, despite new technical refinements, no camera—no matter
how sensitive or accurate its light-metering system—can make the criti-
cal judgments that flower photographers have to make in order to get the
best exposure, not just a good or average exposure. That is why mastering
the skills of metering, interpreting the information a light meter provides,
and knowing when and how to override the automatic setting are still
musts for serious flower photographers.

Light meters are indispensable tools—but not infallible guides—for
gauging the intensity of light in order to expose a subject properly.
Whether handheld or built-in, a light meter contains photosensitive cells
that measure reflected light against an 18-percent-gray standard. Meter
readings are most accurate for subjects that are the equivalent of 18-per-
cent gray, such as green grass, light green trees, brown earth, fall foliage,
suntanned faces, and blue skies. If these subjects were shot with black-
and-white film, they would all appear approximately the same medium-

Exposing a subject according to the meter reading usually provides accurate results when the available light is diffused and colors fall in the neutral-gray range. I encountered just such a shooting situation while making this shot. After mounting my Olympus OM-4T and Zuiko 180mm telephoto lens fitted with a 14mm extension tube, I framed this pansy against a pastel green background that a New York meadow provided. The meter reading indicated an exposure of 1/250 sec. at f/4 on Fujichrome 100 RD film.

While shooting these slightly backlit azaleas in Ohio, I overexposed my subject by one-half stop from a closeup meter reading. The pleasing result: luminous flowers against a contrasting background. Here, I exposed Fujichrome 50 RF film at f/4 for 1/125 sec. using my Olympus OM-4T, my Zuiko 90mm macro lens, and a tripod.

By exposing for the bright area in this high-contrast situation, I was able both to maintain the true color of these Maine lupines and to take advantage of the graphic interest that the dark shadows of nearby trees add to the composition. Exposing Fujichrome 100 RD film at f/8 for 1/125 sec., I made this shot with my Olympus OM-4T, my Zuiko 180mm telephoto lens, and a tripod.

gray color (18 percent) in the final images. But for subjects that are lighter or darker than the 18-percent-gray standard, the meter readings are calibrated to darken the light colors and brighten the dark ones, thereby turning both toward the 18-percent norm.

With experience, you'll learn to interpret meter readings and know when to adjust the recommended camera settings in order to get the exact results you want. Alternatively, you can do what many professionals do: Take the meter reading off a neutral-gray card. These cards are sold in most camera shops. Simply place the card in front of your floral subjects, make sure that the card fills the frame, is in the same light as the flowers you want to shoot, and doesn't reflect any glare back into the lens. The meter reading will eliminate any confusion based on differences in the colors of the flowers.

To take a reading with your manual or semiautomatic SLR camera's built-in light meter, you must first set the film-speed rating of the film; this is the ISO number. Next, depending upon the previsualized image you want to achieve, select either the desired aperture or shutter-speed setting and then turn the other ring until the needles match or the lights signal the proper exposure in the viewfinder.

The new "smart" cameras set the film speed automatically, and their built-in light meters are coupled to the aperture and/or the shutter speed electronically. Exposure settings adjust to changing light conditions instantly. Point-and-shoot models also adjust to variations in light immediately, but you have no way of telling what those chosen settings are. Automatic exposure works best in uniform, diffused light; this is when meter readings are the most accurate.

But for flower photography, being able to control aperture and shutter-speed settings is much more important than adjusting to sudden changes in light conditions. Remember that these settings determine not only exposure, but also sharpness, depth of field, and the way movements

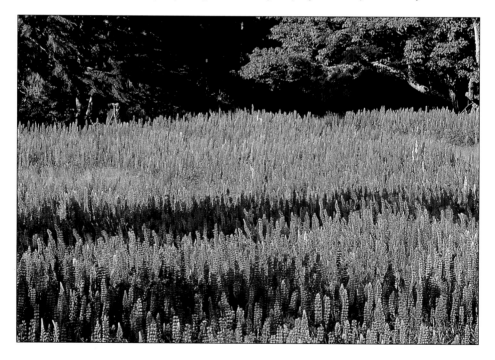

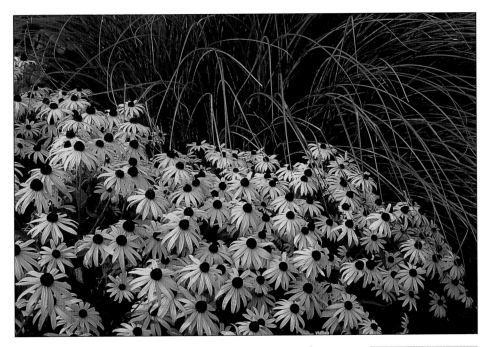

are recorded. This is the reason why cameras that have a manual or pro-
grammable override feature are preferable to strictly automatic-exposure
cameras in terms of achieving the most effective exposure when you
shoot flowers.

Whenever you want to overrule the meter to achieve the most effec-
tive exposure, as well as whenever you must make compromises, you
need to decide what you want to properly expose for and what you can
sacrifice. The following guidelines for overriding meter readings will help
you make these choices.

■ Meter flowers up close or with a spot meter, and then lock in the read-
ing before moving back to compose and shoot.

■ Polarize the scene in order to remove glare or reflections that tend to
fool the light meter; otherwise, you can compensate by overexposing.
The extent to which you do this is determined by the situation and the
kind of image you want to create. This is an art that is best learned
through experimentation and experience.

■ Overexpose very slightly, by less than one f-stop, to emphasize whites
and delicate pastels, especially in flower photographs taken on foggy or
overcast days.

■ Underexpose slightly—once again, by less than one full f-stop, to
reproduce the dark tones of a black iris, purple tulips, or deep-red roses.

■ For negative film, expose for the shadows. For slide film, expose for the
brightest areas. Underexpose slide film to saturate colors in bright light.
Negative film gives you more leeway than slide film does; printing from a
dense, overexposed negative is easier than printing from an underexposed
negative. In addition, slide film is less tolerant than negative film. It is
best to err toward underexposure with this type of film because saturated
colors can withstand being projected—and subjected to the bright
bulb—better than delicate ones can.

■ In backlighting situations, shoot at the meter reading first, and then
overexpose by half a stop.

In order to maintain the
brightness and clarity of
contrasting colors, simply
base your meter reading
on the brighter hue and
then overexpose up to one
full f-stop. This is the tech-
nique I used when pho-
tographing these yellow
coneflowers and dark
green grasses in Ohio.
Working with my Olympus
OM-4T and Zuiko 35mm
lens mounted on a tripod, I
exposed for 1/60 sec. at
f/16 on Fujichrome 100
RD film.

When you want to emphasize the shape of a flower against a background of similar color, you should take advantage of contrasting light. For this shot, I metered off the neutral tones of California's Anza Borego Desert and then underexposed by one-half stop to create a soft background for the backlit flower. I used my Olympus OM-4T, my Zuiko 90mm macro lens, and a 39mm extension tube, and mounted this setup on a tripod. I then exposed Fujichrome 100 RD film at f/5.6 for 1/60 sec.

When I came across this dandelion in Colorado, I decided that I wanted to reveal the flower's structure. In order to create the silhouette, I photographed the dandelion against a bright background. Achieving this dramatic effect simply required exposing for the background, not the flower. Working with my Olympus OM-4T and my Zuiko 90mm macro lens, which I'd mounted on a tripod, I exposed for 1/125 sec. at f/5.6 on Kodachrome 64.

After taking a closeup meter reading of this orchid at The New York Botanical Garden, I overexposed by half a stop. I wanted to achieve good color saturation despite the bright background, and I knew that this approach would ensure that result. Having mounted my Olympus OM-4T and my Zuiko 180mm telephoto lens fitted with a 39mm extension tube on a tripod, I exposed for 1/125 sec. at f/5.6 on Fujichrome 100 RD film.

■ Bracket to get the best results, taking several shots at slightly different settings within a reasonable range of the meter reading. This is generally up to one f-stop in either direction of the reading.

■ On the other hand, to get the best possible results when shooting in high-contrast situations, such as in a forest or a garden on a bright, sunny day, meter the highlights in the flowers with the lightest and darkest colors. Then if the two readings are within 2¹/₂ f-stops, split the difference. If the discrepancy is three or more stops, expose for the most important color.

■ Underexpose brightly illuminated foreground flowers set against a dark background by up to 1¹/₂ f-stops.

■ Shoot at the indicated meter reading if you're photographing foreground flowers in shade with a bright background, and then bracket toward overexposure.

■ If a flower has an interesting shape, try a silhouette by metering the background and bracketing toward underexposure.

■ Reduce contrast with small electronic flash units and/or diffusers to soften highlights, as well as with reflectors, which kick light back into shadows. A diffuser can simply be a store-bought or an improvised translucent screen that diffuses light.

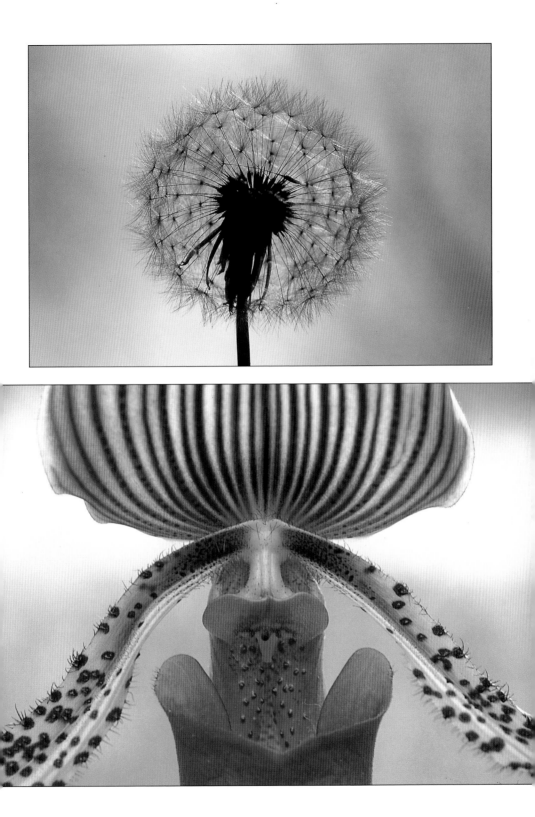

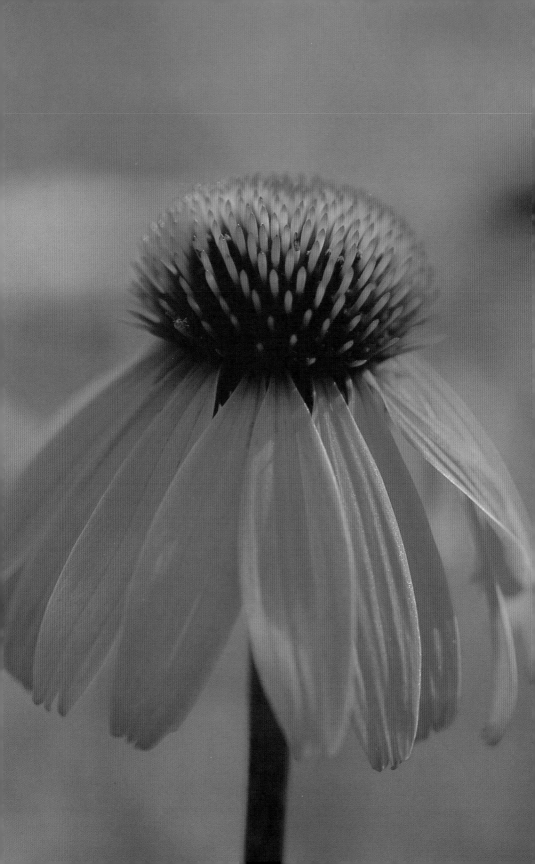

CHAPTER 3

Shaping an Aesthetic Design

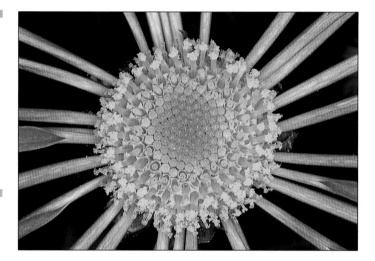

To sharpen the contrast of colors in this Ohio scene, I shot this gaudy pink cone-flower with my Zuiko 90mm macro lens wide open. The large aperture setting of f/2.8 threw the green background out of focus. I mounted my Olympus OM-4T on a tripod and exposed Fujichrome 100 RD film for 1/250 sec.

Shooting in New York's Old Westbury Gardens, I spotlighted the dazzling colors of this chrysanthe-mum with my powerful Olympus T-32 electronic flash. With my Olympus OM-4T, my Zuiko 90mm macro lens, and a 75mm extension tube mounted on a tripod, I exposed Fujichrome 100 RD film for 1/60 sec. at f/16.

Flower photographs must be more beautiful than the flowers themselves, and they have to transcend reality through an aesthetic vision. To accomplish such a transformation is no mean feat. Beyond engaging your imagination and your understanding of natural light, you'll need to shape each aspect of your composition, making decisions about everything from how you want the colors to look, to how best to arrange the shapes into a dynamic design, to exactly which elements should and shouldn't be sharp.

The rich red color of this tulip, deepened by slight underexposure, dominates the aesthetic design of this tightly framed composition. For this floral portrait, which I made at PepsiCo World Headquarters in New York, I mounted my Olympus OM-4T and Zuiko 90mm macro lens on a tripod. The exposure was 1/8 sec. at f/11 on Fujichrome 100 RD film.

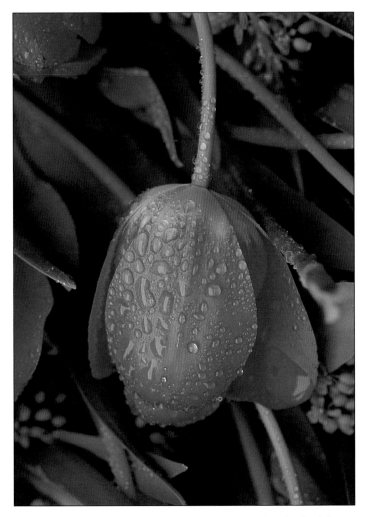

Even professional photographers don't always know what the final design of an image will be, nor would they want that kind of certainty. To some extent, the process of mapping the design of a flower photograph is one of discovery, experimentation, surprise, and serendipity. The experienced nature photographer develops a clearer sense of what can and can't be done, but the final image is likely to emerge only after some trial and error. Photographers may move around to find the best perspective, look through the viewfinder to see how the various elements combine, and push themselves to try something they've never attempted before.

As a flower photographer, you'll home in on particular elements that seem strong or evocative as you analyze potential subjects. These features will become the most important, and the weaker elements of a subject will be downplayed. A flower's color may be the key to one image, while the texture of the surrounding foliage may be the draw in another. Only after you identify the essential element can you decide on the equipment and techniques that will spotlight it. As you consciously study and choose, emphasize and eliminate, you bring order and shape to random, chaotic nature.

COLOR

When it comes to color, there is more than meets the eye. The brilliant scarlet of a rose quickens the heart. The soft pink and amber of a sunset soothe the soul. Color is everywhere, dazzling the human eye and enriching people's perceptions. And color is often the magnet that draws people to flowers in the first place.

Color plays such a central role in the aesthetic design of flower photographs that getting the color right is vital. Bright, intense colors must be fully saturated to have the greatest impact; this usually requires some underexposure, especially if you're shooting in harsh midday light. Soft, muted colors, on the other hand, look best in diffused light. You may even want to overexpose them slightly in order to emphasize their delicate tonalities.

You can allow one color to dominate the frame to make an image forceful and dramatic, or you can combine several colors that support one another aesthetically. If the colors contrast with one another in intensity, expose for the one that is most important to your photograph. But beware of including too many different hues in one composition: this could weaken the photograph's impact. Ordinarily, a simpler choice of colors produces a stronger image.

More important than the way a color looks is the way it is rendered on film. Use your knowledge of exposure techniques, film variations, filters, and electronic flash to help you record colors as you want them to appear in your final photographs. It takes practice to know just which combination of ƒ-stops, films, and filters will translate the actual color you see into the precise color you hope to capture on film.

Although accomplished photographers have made outstanding black-and-white images of flowers, most floral images appeal on the basis of color. How colors work within the picture frame, singly or together, as part of the design of flower photographs is a key aspect of their success.

I photographed these tulips and grape hyacinths in Holland. To achieve an abstract study of disparate colors and textures, I shot my subjects from above with my Olympus OM-4T and Zuiko 90mm macro lens mounted on a tripod. Here, I exposed Kodachrome 64 for 1/125 sec. at ƒ/5.6.

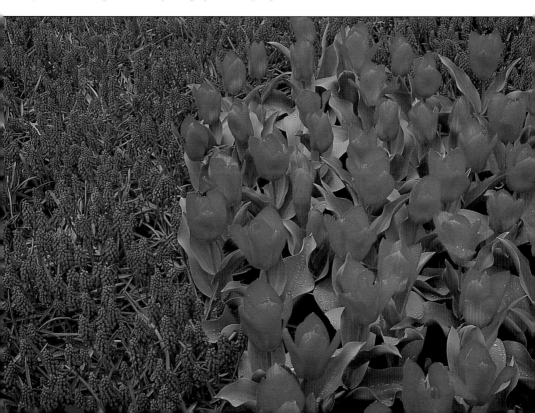

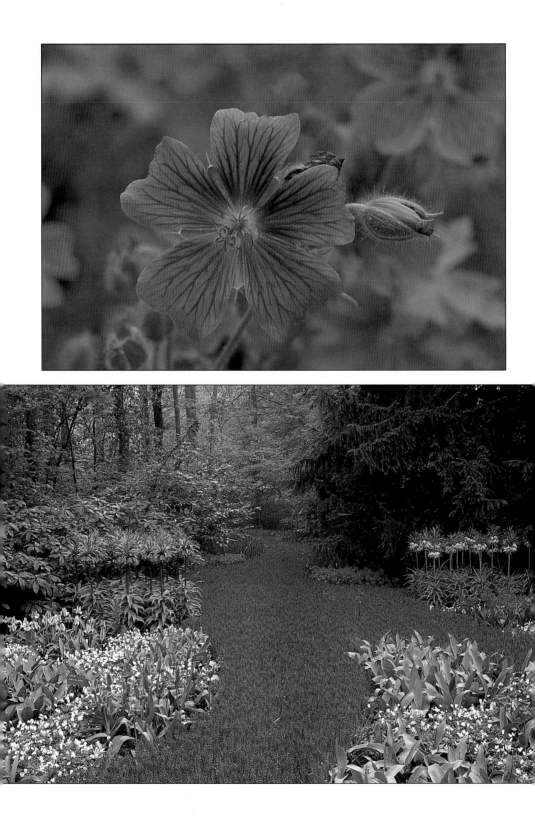

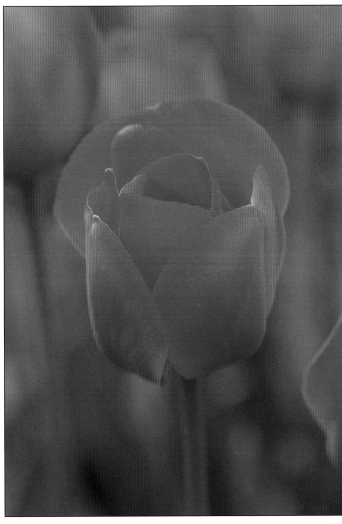

Shades of blue benefit from such films as Fujichrome 100 RD film, my choice for this image of a ground-cover flower. Experiment to see which films suit your preferences for rendering various colors. I exposed the film at f/8 for 1/15 sec. and used my Olympus OM-4T and Zuiko 90mm macro lens for this shot, which I made in Texas.

A high perspective reveals the design of this colorful Dutch bulb garden, and the diffused light of an overcast day saturates the greens and purples. I photographed these grape hyacinths in Lisse, Holland, with my Olympus OM-4T and Zuiko 35–70mm zoom lens. The exposure was 1/60 sec. at f/8 on Fujichrome 100 RD film.

This red tulip stands in sharp contrast to its complementary green color. For this vivid rendering, shot in Wisconsin, I mounted my Olympus OM-4T and Zuiko 90mm macro lens on a tripod. I then exposed the scene for 1/30 sec. at f/5.6 on Fujichrome 100 RD film.

Once you know how you want the colors to appear, you must master the technical steps that can take you from the raw materials of flowers and light to the exact image you have in mind.

FRAMING AND FORMAT

The natural world is a fairly chaotic place visually. The human eye is bombarded with competing stimuli from every direction. By the very act of picking up a camera and pointing it in a certain direction, photographers attempt to order the randomness of the world.

Shaping an aesthetic photographic composition begins with the act of framing. With every shot, you must decide what belongs inside the box delineated through your viewfinder. Barring the use of computer manipulation, as a flower photographer you don't have a painter's license to adjust and alter reality. You can, however, be selective by becoming as objective as the camera. The following suggestions will help you.

■ **Simplify.** Don't try to include too much. Let color and form dominate your compositions. Look carefully and thoughtfully to both the edges

When I came across this wonderful lupine in California's East Mojave Desert State Park, I knew that a vertical format would best display its beauty. I made this closeup with my Olympus OM-4T and Zuiko 90mm macro lens mounted on a tripod. I exposed Kodachrome 64 for 1/250 sec. at f/8.

In order to smoothly combine the foreground undergrowth of azaleas and bluebells with the background of trees in this Winterthur, Delaware, forest, I decided on a vertical format. I mounted my Olympus OM-4T and Zuiko 35–70mm zoom lens on a tripod and exposed Fujichrome 50 RF film for 1/15 sec. at f/16.

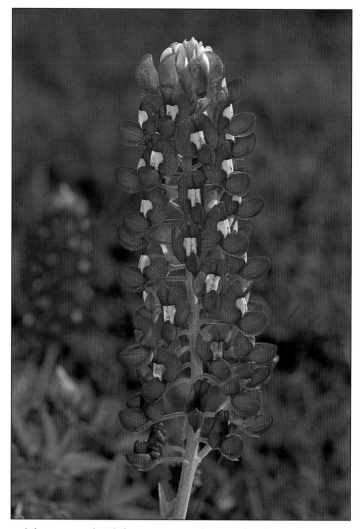

and the corners of each frame, noticing elements that don't contribute to the image, such as trash cans, leaves, twigs, grasses, people, telephone poles, and cars. Then move, change lenses, or throw parts of the picture out of focus so that only what is absolutely necessary remains sharp when you press the shutter-release button.

■ **Change perspective.** Break the habit of looking at flowers and gardens from an upright, eye-level viewpoint. Move in every available direction—around, behind, up, and down—to find unusual angles for framing your shot. A view from the rear may prove more interesting than one from the front, just as a view from below may be more intriguing than either a head-on perspective or a view from above.

■ **Move in close.** Too many photographers shoot flowers from too far away. Get close enough—either physically or by changing lenses—to fill the frame with exactly what attracted your eye in the first place. You might even try extra-tight framing that portrays incomplete flowers as if they were disembodied forms or planes of color. Keep in mind that a part may say more than the whole.

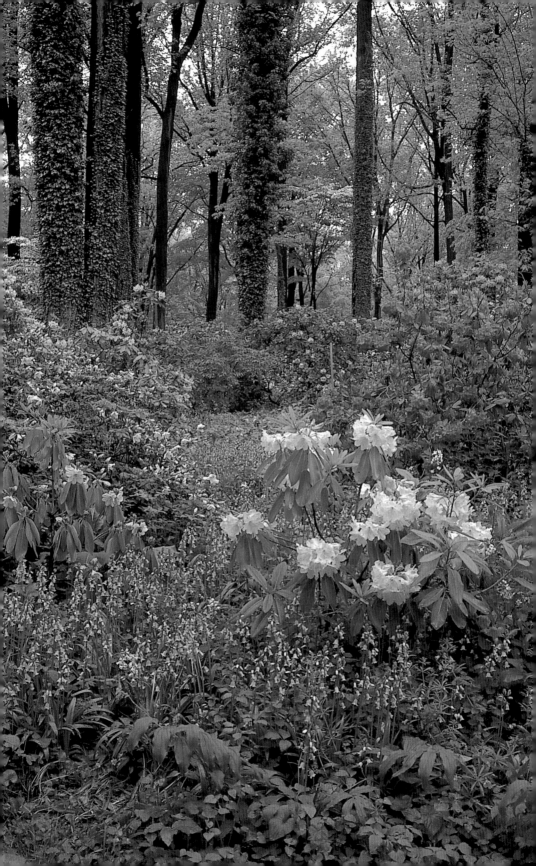

■ **Experiment with horizontal and vertical formats.** Photographers favor the horizontal format because holding a camera in this position seems more natural. Also, people tend to experience the visual world horizontally. Break this pattern by looking at every potential subject or scene both horizontally and vertically before pressing the shutter-release button. Changing formats may eliminate unwanted distractions or reduce an unattractive expanse of sky. Whatever the format, take an extra moment to be sure the horizon line is level—unless you deliberately want it not to be horizontal.

There is no end to framing possibilities. Let your individual vision guide you. And then make sure that the composition you see through your camera viewfinder is exactly what you want to record on film.

DEGREES OF SHARPNESS

It is hard to produce absolutely sharp flower photographs. Flowers are often tossed about in the breeze, frequently grow in clusters, have shapes

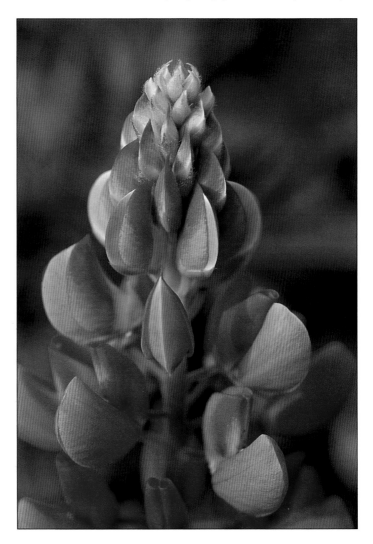

that make focusing difficult, or are shot at close range, which limits depth of field. But in truth, the aesthetic designs of flower photographs often demand less-than-absolute sharpness, and some blurring can actually enhance many flower pictures. So before you press the shutter release, focus precisely and think carefully about the degree of sharpness you want in your image.

Your first inclination will probably be to keep everything as sharp as possible. Maximum sharpness is desirable whenever texture and detail are important. Naturally, it is undesirable when you have a jumble of confusion in the background. You can increase sharpness several ways.

■ Place your camera on a sturdy tripod, and use a cable release when shooting.

■ Use a standard or wide-angle lens in order to increase depth of field.

■ Choose the film that produces the sharpest images possible. These are usually such slow films as Kodachrome 25, Fujichrome Velvia, and Ektachrome Lumière.

The shallow depth of field that my Zuiko 180mm telephoto lens produced separated this Israeli tulip from its grassy background. Shooting Kodachrome 64 with my Olympus OM-4T, I exposed for 1/250 sec. at f/5.6.

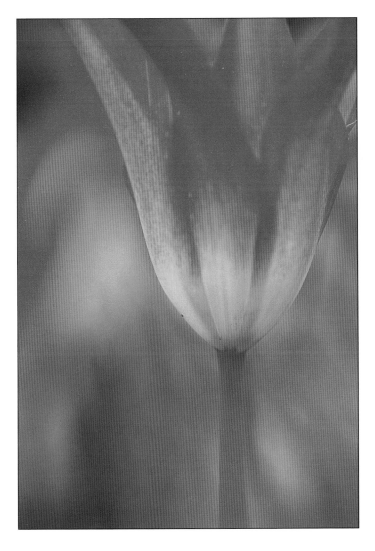

I photographed these grape hyacinths in Holland. The individual flowers merge into a deep purple arrow that draws the viewer's eye into the distance of this Dutch garden. Here, I used my Olympus OM-4T, my Zuiko 35–70mm zoom lens, and a tripod. The exposure was 1/30 sec. at f/16 on Fujichrome 100 RD film.

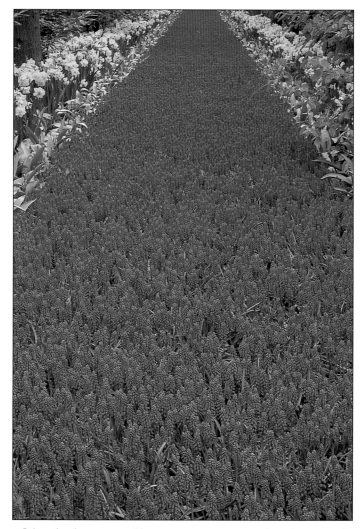

■ Select the sharpest possible aperture setting on your lens. As a general rule, this, the smallest aperture, is two to three stops down from the maximum, or f/5.6 to f/11.

■ Set the shutter speed to at least 1/125 sec. to stop movement. If necessary, add light with a reflector or an electronic flash unit, or follow the motion pattern in your viewfinder and try to snap at the turning point in the sway. Learn to be patient: the wind will eventually subside. But it may subside for only a second or two, so be ready to shoot at those critical moments.

■ Focus accurately, particularly when you use wide-open apertures and fast shutter speeds.

■ Expose properly. Films that are overexposed or underexposed tend not to look sharp, especially in details at the bright or dark extreme. Create the impression of greater sharpness by utilizing high contrast in light or color between a subject and its background.

Of course, you may not be able to coordinate all of these techniques at the same time, so you should choose the combination that works best

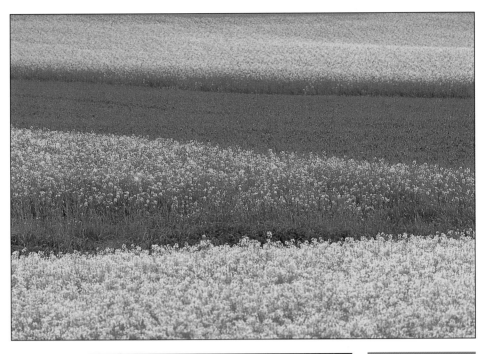

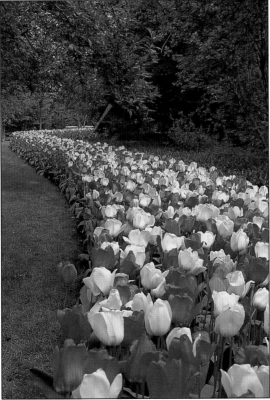

My powerful Zuiko 50–250mm zoom lens transformed this canola field, which I came across in France, into graphic blocks of yellow and green. Shooting with my Olympus OM-4T, I adjusted my lens to its longest setting, 250mm, and exposed Fujichrome 100 RD film for 1/125 sec. at f/8.

I discovered this tulip bed in Holland. After I considered various compositions, I decided to exaggerate the receding curve of flowers. To achieve this effect, I put my Zuiko 35mm wide-angle lens on my Olympus OM-4T and mounted them on a tripod. The exposure was f/16 for 1/15 sec. on Fujichrome 100 RD film.

in the particular situation you face. You may want some parts sharp, and others out of focus. Sometimes it won't be possible for you to get everything sharp. When you have to make choices, focus accurately on the most essential element in the image. For example, it is important that the pistils or anthers inside a flower are sharp even if parts of the petals aren't.

If you notice distracting details behind your subject, you may decide on an aesthetic design that calls for a sharp foreground flower with a blurred background. To achieve this effect, move in as close as possible for a tighter composition, and use either a macro or moderate-telephoto lens set at its largest aperture. Then as you look through the viewfinder, keep in mind that the aperture is open to its widest point. If you like what you see in terms of the limited depth of field, leave the aperture at this setting. If you don't, adjust the size of the aperture until you get the result you want.

Another possibility is a slice of the scene, in which a central portion of the frame is sharp, but the foreground and background are blurred. This is an interesting variation to try when you're shooting in a field or photographing a broad expanse of flowers. To capture a slice of the scene, use a telephoto lens set at its widest aperture and focus on a point about one-half to one-third of the way into the frame.

At other times, you may find yourself shooting in windy conditions. If you can't fight the breeze, use it to your advantage. Let the movement of the flowers register as an impressionistic blur by using a shutter speed of 1/15 sec. or slower. To prevent camera shake, mount your camera on a tripod. As you continue to shoot photographs that deliberately aren't sharp, you'll discover that a bank of colorful flowers swaying in the breeze can produce an enchanting image.

COMPOSING WITH LINES, FORMS, AND SHAPES

Learn to look at and analyze every composition in terms of its abstract qualities. By viewing individual flowers, groups of flowers, and entire fields of flowers as an interplay of lines, forms, and shapes, you'll strengthen the graphic impact of each floral picture you shoot. This is an important part of the process of composing well.

Lines connect and organize the space in your frame, creating a flow of movement from one point to another. You'll find that a line may define a petal's edge, delineate the meeting point between two contrasting colors

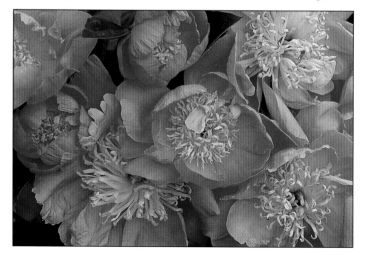

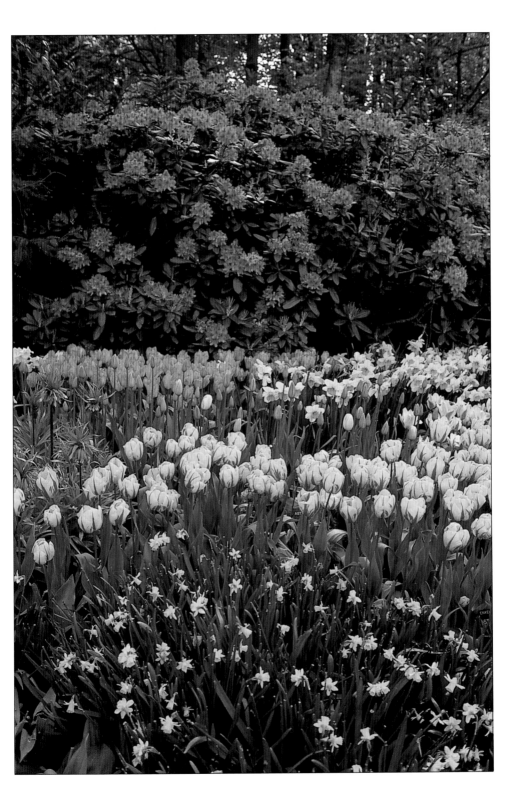

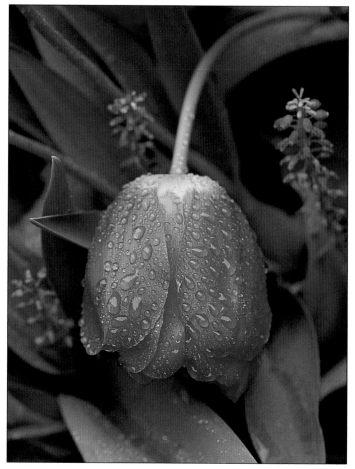

in neighboring flowers, hug the contours of the landscape, or follow a walkway in a garden. In addition, lines can be either real or implied. For example, a country road is a real line, while the point where two flowers meet suggests an implied line.

Whatever their source, lines guide a viewer's eye along a smooth path, generating involvement and interaction with your image. And whether such lines are real or implied, they should become expressive tools in your flower photography. Although horizontal lines are relatively static, they tend to convey a sense of order and calm. Vertical lines, made, for example, by tree trunks or the stems of tall flowers, draw a viewer's eye upward. This is particularly true when you shoot from below. Converging, radiating, and curved lines are dynamic, producing varying degrees of tension and moving the eye into and around the picture frame.

The effective use of shapes and forms balances your flower photographs. While many flowers are circular, others come in more exotic shapes, such as bells, trumpets, and clusters. And fields of flowers can take on innumerable forms—everything from clusters of neat rows to extravagant, free-form displays—depending on their natural or planted arrangements.

In general, a few bold floral shapes that fill the frame are preferable to a few scattered smaller spots. This is why it is so important to move as

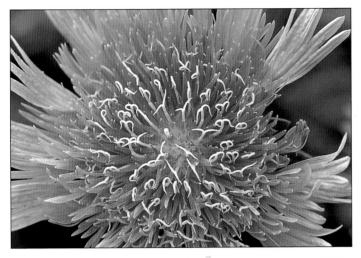

The combination of a small aperture and precise focusing on the white filaments of this flower ensured maximum sharpness in this extreme closeup. I made this shot at Winterthur, Delaware, with my Olympus OM-4T and Zuiko 90mm macro lens mounted on a tripod. The exposure was 1/125 sec. at f/11 on Kodachrome 64.

You can bring out the texture of flowers by taking advantage of the contrast between a well-lit subject and a dark background. This was the approach I utilized for this picture of fairy dusters, which I found in Anza Borego State Park in Death Valley, California. Shooting with my Olympus OM-4T and Zuiko 90mm macro lens mounted on a tripod, I exposed for 1/125 sec. at f/5.6 on Ektachrome 64 Professional EPX film.

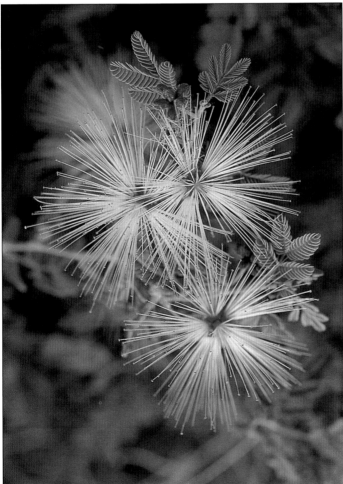

close as possible to your flower subjects. If you must remain at a distance from the flowers, use a telephoto lens to effectively bring them closer to you. You can also compose an image of a profusion of flowers in such a way that collective shape appears to be a band or ribbon of color. Yet another alternative is to create a dramatic shape by setting your floral subject against a dark, out-of-focus, or uniform backdrop. The negative space of the background then creates another shape to balance that of the flower.

REVEALING PATTERNS AND TEXTURES

Patterns and textures lend flower photographs a special immediacy and tactile quality. Patterns refer to the regular repetition of colors and shapes across the canvas of the photograph. For example, you might find a tight grouping of tulips in a bed or a field of lupines appealing. Patterns provide additional visual interest and permit the viewer's eye to explore and roam around the photograph. Floral patterns are best defined by contrasting colors or light, which increase definition, although they depend primarily on the colors and shapes of the flowers themselves.

In natural settings, flowers may also occur in less rigid patterns. These rhythmic echoes of color and shape tend to create a freer visual flow across the picture plane. Making expressive use of these rhythms depends on your imaginative ability both to balance and to organize irregular elements within the picture frame.

Textures give a visual "feel" or "touch" to flower photographs. Textures range from the fuzzy pollen grains that dust a flower's delicate internal structures, to the spiny surface of a cactus, to the softness of rose petals. Capturing these floral textures on film depends on sharpness and the effective use of changing light conditions. Sidelighting, with its well-defined shadows, reveals texture best while frontlighting flattens it. As such, you should select a camera angle that will accurately represent its three-dimensional form.

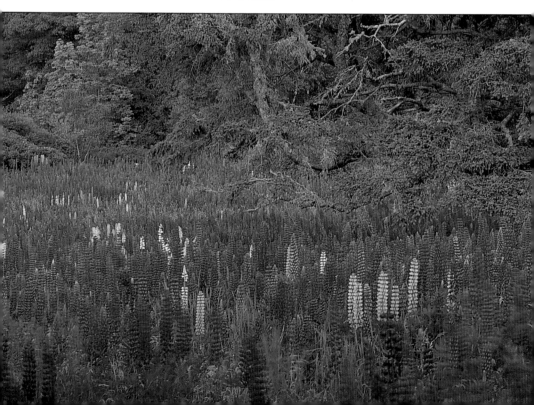

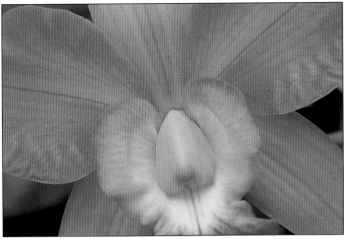

One advantage of an SLR camera is the ability to change lenses. I couldn't have taken this orchid closeup, made at The New York Botanical Garden, without a macro lens. Here, I put my Zuiko 90mm macro lens on my Olympus OM-4T and then mounted them on a tripod. Next, I exposed Fujichrome 100 RDP film for 1/8 sec. at f/16.

I wanted to reveal the smooth, delicate texture of this white iris, so I had to get in close. In order to achieve this, I mounted my Olympus OM-4T and my Zuiko 180mm telephoto lens fitted with a 50mm extension tube on a tripod. Shooting in Montclair, New Jersey, I exposed Kodachrome 64 for 1/30 sec. at f/16.

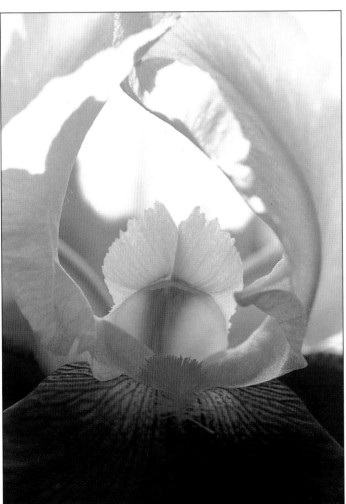

Tools and Techniques

A medium-wide-angle lens enabled me to frame this closeup vignette of a lupine and a portion of the surrounding meadow in Bar Harbor, Maine. Shooting with my Olympus OM-4T and Zuiko 35mm wide-angle lens, which I'd mounted on a tripod, I exposed for 1/30 sec. at f/16 on Fujichrome 100 RD film.

I wanted to achieve maximum depth of field for this shot of a Colorado mountain meadow filled with fireweed and Indian paintbrush. I mounted my Olympus IS-3, which has a built-in 35–70mm zoom lens on a tripod. Next, I set my aperture-priority camera to a high f-stop. The shutter speed was then calculated automatically. I exposed Fujichrome 100 RD film for 1/60 sec. at f/16.

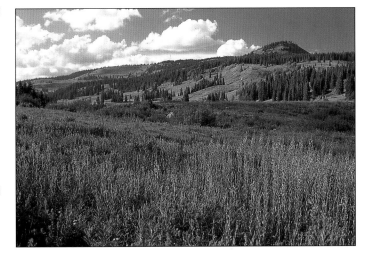

One of the biggest mistakes photography buffs make is spending a great deal of money on equipment without fully defining exactly what gear they need. You would be much wiser to develop your photographic skills to the utmost with the equipment you currently have. Then, when these pieces of equipment stop serving your needs, you can feel free to make any new purchases carefully, buying the best that you can afford of a few essentials.

I needed an ultrawide-angle lens in order to integrate the gaudy tulips in the foreground with their garden setting. Working in Lisse, Holland, I used my Olympus OM-4T and my Zuiko 21mm wide-angle lens. The exposure was 1/30 sec. at f/22 on Fujichrome 100 RD film.

Remember that your equipment is there to serve your creativity. It neither acts as a substitute for an aesthetic vision, nor guarantees aesthetic results. Camera equipment, like the tools of any craft, is merely a means to an end. The key is to let your equipment become an extension of your eye, enabling you to see more imaginatively than your unaided eye would see and to control the final product.

Your essential flower-photography "tool kit" should consist of a camera—preferably a 35mm single-lens-reflex (SLR) camera that is easy to carry and use—a tripod, and a few lenses—especially a macro lens for true closeups. A few filters will expand your repertoire and add pizazz to your photographs. Choose film to match the conditions you are likely to encounter with respect to color, contrast, and speed. Just a notch below essential is an electronic flash unit. Other gadgets may prove useful; when they do, be sure that you buy the highest-quality products you can afford.

Before you go into the field, check that your equipment is in proper working order. Start with clean equipment and fully charged batteries. Pack lens tissue and plastic bags to touch up and protect your gear in the event of blowing dust or rain. Arrange your camera bag so items are secure in transit and easy to find, and return them to the same place after you finish using them. Make sure that you have all the equipment you might need, but don't take so much that you quickly tire carrying it. Keep it simple, light, and easy so that you control your gear, and not the other way around.

CAMERAS

If you are in the market for a new camera for shooting flowers, the modern SLR camera is by far the camera of choice. Today's SLRs have so many advantages that nearly all professional flower and nature photographers turn to them. These technological marvels are compact, light, maneuverable, and affordable. They come with a wide variety of inter-

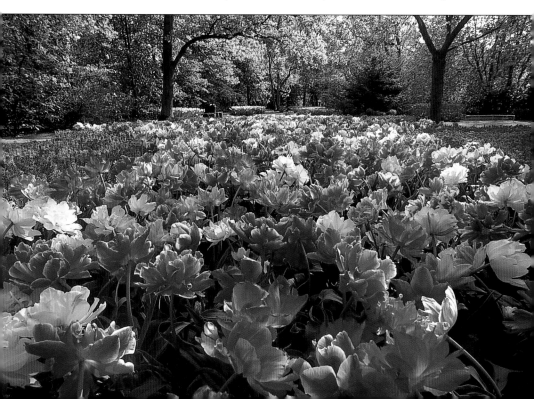

For this shot of petunia petals on chrysanthemums, I set my camera's exposure-compensation dial to –1/2. I wanted to underexpose this image in order to achieve richer, more saturated colors. Using my Olympus IS-3 with its built-in 35–70mm zoom lens mounted on a tripod, I exposed for 1/15 sec. at f/16 on Fujichrome 100 RD film.

changeable lenses, as well as with super-sophisticated through-the-lens (TTL) metering and automatic-exposure systems. SLRs have even simplified closeup photography by offering new close-focusing lenses and TTL-controlled flash capabilities.

The only SLR feature that is more of a hindrance than an advantage for flower photography is automatic focusing. This is geared to shooting quickly under rapidly changing conditions, such as those found in sports photography or photojournalism. Flower photography relies much more on precise focusing than on capturing the moment. So if you are serious about flower photography, be sure that your SLR camera system has manual-focusing capability.

An SLR camera that will be used for flower photography should have the following features as well:

■ Off-the-film-plane metering (OFM) for greatest exposure accuracy. This system takes readings at the film plane, which is where the exposure occurs, not at some other location.

■ A choice of matrix, center-weighted, and spot metering, for getting the most accurate exposure whether you're shooting scenics, vignettes, or details. A matrix meter takes readings across the film plane and balances them for a precalculated, "best" average exposure. On the other hand, a center-weighted meter is, as its name implies, weighted toward the middle of the frame, giving priority to a centered subject. And a spot meter, obviously, takes a narrow reading, thereby accurately measuring a specific point in the frame.

■ A choice of shutter-priority, aperture-priority, and manual-metering programs, to give you control over motion and depth of field. Respectively, these programs enable you to control the shutter speed, the ƒ-stop, or both.

■ An exposure-compensation mechanism that lets you override the automatic-exposure settings, which in turn gives you greater control over color rendition.

■ A preview button to check the depth of field at the aperture setting currently in use.

Point-and-shoot cameras also have a place—albeit a lesser one—in flower photography. Originally designed for taking snapshots, these easy-to-handle, completely automated (and most affordable) cameras have become more sophisticated; they can now produce clear, sharp, and properly exposed nature images. Point-and-shoot cameras offer many

automatic features: focus, exposure, film loading and unloading, film advancing and rewinding, and built-in flash.

Point-and-shoot cameras come in three basic models. The simplest have a single lens with a fixed focal length, ordinarily 38mm, which limits its use to scenics and vignettes. Dual-lens models come with both a standard, or normal, lens with a focal length of 40–50mm and a telephoto lens with a focal length of 60-80mm. Zoom-lens models, whose focal lengths range from 28mm to 150mm, provide the most versatility.

Before you buy one of these cameras for your flower photography, however, you need to know that all point-and-shoot models have limitations. These include lesser-quality optics than manual 35mm cameras have and a specific, sometimes narrow focal range. Point-and-shoot cameras also lack an override capacity and don't allow you to change lenses. All of this means that you have less control of the final image, which is a genuine loss in flower photography.

The most appropriate point-and-shoot cameras for flower photography have the following additional features:

- For greater focusing control, a spot autofocus feature.
- For off-center compositions, a focus lock (check your camera manual, and follow the directions in it).
- For closeups, macro capability to focus down to 10 inches or less, as well as a fill-in-flash mode (see page 77) and an exposure-compensation feature for backlighting conditions.
- For scenics, a panoramic format to create an ultrawide-angle effect.

In addition, be sure your point-and-shoot camera accepts the full range of films, from ISO 25 to ISO 1600, and has a mid-roll rewind capability in case you want to switch films partway. As you can see, you have a wide variety of camera options to choose from, so it is wise to do a little research before you invest. Photography magazines regularly test the latest equipment. Check a recent issue before you shop.

CHOOSING THE RIGHT LENS

Most professional photographers argue that choosing the right lens is much more important than choosing the right camera because lens selection reflects your understanding of the image you want to create. There are five basic categories of lenses: standard, wide-angle, telephoto, macro, and zoom. All have value and purpose in flower photography depending on the

Here, I used my Zuiko 180mm telephoto lens fitted with a 25mm extension tube to blur the background behind this Israeli cleome. This combination produced the desired result: to separate the flower from its desert surroundings. Shooting with my Olympus OM-2N camera mounted on a tripod, I exposed for 1/125 sec. at f/4 on Kodachrome 64.

intended scope of your image, the desired depth of field, and the size you want your subject to be on the film plane. For example, a subject shot from the same given distance will appear smallest when you use a wide-angle lens and largest when you use a telephoto lens.

Standard 50mm lenses used to be routinely sold with camera bodies. If you can, avoid purchasing the standard lens for your camera; buy a 50mm macro or a 35–70mm zoom lens instead. These lenses provide the same scope as the standard lens and at the same time offer so much more, such as closeup capability or flexibility in composing.

Wide-angle lenses take in the broadest view and provide the greatest depth of field. They are ideal lens choices when you can't move back in a garden, decide to show an entire garden or a natural setting with maximum sharpness throughout, or want to dramatize flowers at a relatively close range in front of a more distant scene.

Telephoto lenses, on the other hand, offer the narrowest perspective and the shallowest depth of field. They let you scan a large area by panning the camera without having to walk around, which is a real time-saver. With a telephoto lens, you can enlarge floral subjects and fill the

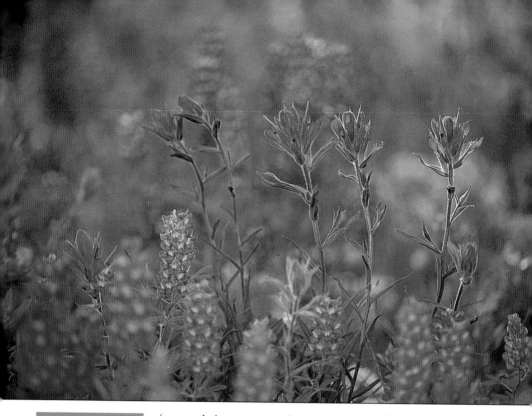

frame with distant ones, picking out groupings of flowers to create strik-
ing compositions of shapes, colors, or textures.

Telephoto lenses provide you with another option: you can separate
foreground subjects from their surroundings, throwing the area behind
your subject out of focus. This enables you to create an interesting visual
effect or simply to disguise an unappealing backdrop. In addition, you
can compress the space between foreground and background areas with
these lenses. As a result, fields of flowers appear denser and more colorful
on film than they actually are.

Macro lenses are your best choice for floral closeups. These lenses are
designed to be sharpest at close range, down to 1 inch. True macro lens-
es—which produce an image of your subject that is at least half-life-size
on film—come in several focal lengths, such as 50mm, 90mm, and
200mm. Each of these macro lenses provides the same degree of magnifi-
cation at different working distances. For example, a 50mm macro lens at
a shooting distance of 4 inches produces the same magnification as a
90mm macro lens at a distance of 8 inches and a 200mm macro lens at
16 inches. Some macro zoom lenses on the market focus closer than
standard zoom lenses do, but these aren't true macro lenses because they
don't produce images that are at least half-life-size.

Zoom lenses certainly have their advantages. In terms of composing
an image, these lenses are the most versatile. Furthermore, because they
can take the place of several other lenses, zoom lenses save you weight
and bulk when you go out to shoot, as well as money. The three most
useful zoom lenses have the following focal-length ranges: 35–70mm,
50–250mm, and 21–35mm.

The main disadvantage of using zoom lenses is that they aren't as fast
as most fixed-focal-length lenses. This reduces your ability to use fast
shutter speeds, especially in dim light. Therefore, you should buy the

fastest zoom lens you can afford. To compensate for a slow lens, simply use one of the new super-high-speed films for your flower photography.

The future looks bright for zoom lenses. The trend is toward extending their range of focal lengths—an excellent 35–350mm zoom lens is already on the market—and make the lenses more compact. Soon, you may find that a macro lens and a zoom lens are the only lenses you really need to photograph flowers.

FILMS

One decision that is more important to flower photography than you may realize is your choice of film. Films can make a noticeable difference in your final images, so consider the following factors carefully each time you prepare to shoot flowers. If you have several camera bodies, try photographing the same floral subjects in the same light using different films. If you have just one camera body, get a recent photography magazine and look at the tests that are regularly published to show differences

Shooting on a rainy day at The New York Botanical Garden, I selected Fujichrome 50 RF film to make the pink color of these peonies more vivid. This effect compensated for the dull illumination. Shooting with my Olympus OM-4T and Zuiko 50mm lens mounted on a tripod, I exposed for 1/30 sec. at f/11.

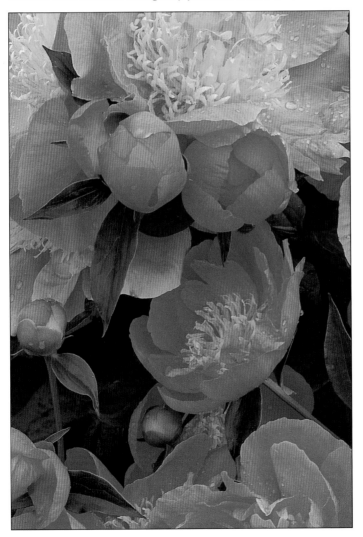

Wanting to record the true blue/purple color of this Maine lupine, I decided to shoot Fujichrome 100 RD film. I knew that this particular film would render the color accuracy I wanted. I made this shot with my Olympus OM-4T and my Zuiko 90mm macro lens, exposing for 1/125 sec. at f/4.

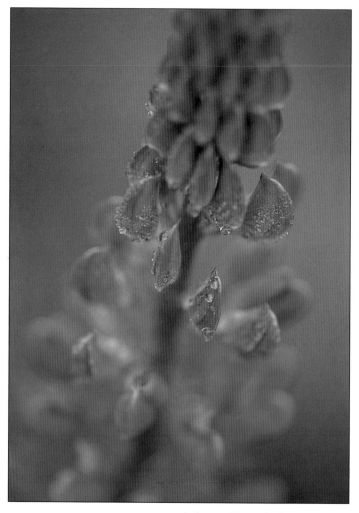

among comparative test strips, particularly new films, which are continually being developed.

Perhaps first and foremost, films differ in the way they represent colors. Kodachrome is known for its rich reds, yellows, and browns. Both Fujichrome and Ektachrome, on the other hand, produce brilliant blues and greens.

When deciding which type of film to use, you must also consider film speed. In general, you should use the slowest film you can, within the film-speed range from ISO 25 to ISO 100, for the equipment and light you have. If you have slow lenses or face dim light conditions, a fast film can save the day. Kodachrome 200, Ektachrome 400, and Fujichrome 400 are excellent fast films. An alternative is to push a slow-speed film: shoot the entire roll at an underexposure of up to two f-stops and compensate during processing to achieve proper exposure. Be sure to indicate on the film canister that you pushed this particular roll so you can identify it later and instruct the processing lab to develop the film properly. Keep in mind, however, that not all films can be pushed; this technique doesn't work with Kodachrome films.

In general, the slower the film, the tighter its grain structure and the sharper the final images will be. However, the new fast films are much sharper than their predecessors were. Still, if sharpness is a priority, choose a film with an ISO rating of 100 or less. On the other hand, if you want to create a grainy effect, select a film with a very high film-speed rating: ISO 800 to ISO 3200. The higher the ISO rating, the larger the silver particles in the film that cause a grainy look.

Your choice of film is also determined by a film's tolerance to contrasty light. If you're photographing flowers in very bright light and you want to retain detail in the dark shadow areas, you'll need a film that reduces contrast. Certain films, such as Kodachrome 25, Fujichrome 50, Ektachrome Elite, and Ektachrome Lumière have enough latitude to maintain clarity in both bright and dark areas. Low-contrast films also soften pastels. On the other hand, in dim light, you may want to increase contrast in order to delineate colors of various brightnesses or to create apparent sharpness. Because Fujichrome Velvia, Ektachrome EPZ, and Kodachrome 200 emphasize contrast, they are good choices for shooting situations in which the illumination isn't bright.

Finally, you have to decide whether print or slide film is more appropriate for you. Print film gives you inexpensive, instant results that you can send to family and friends. For commercial purposes, however, slides are a must. This is also true if you want to project your flower photographs. Of course, you can always have prints made from slides, but such copies are more expensive than those produced from negative film.

With the exception of individuals working with large-format cameras, serious flower photographers tend to use slide film for several reasons. In general, slide film is sharper and offers better color saturation than print film does. However, if the final image will appear in print form, many professionals use print film. They consider such new films as Kodak's Royal Gold 100 and Fuji's Reala to be the best of the print-film options.

Fujichrome Velvia makes the greens and reds of this tulip field vibrant. Shooting in Holland with my Olympus OM-4T and my Zuiko 21mm wide-angle lens mounted on a tripod, I exposed at f/22 for 1/30 sec.

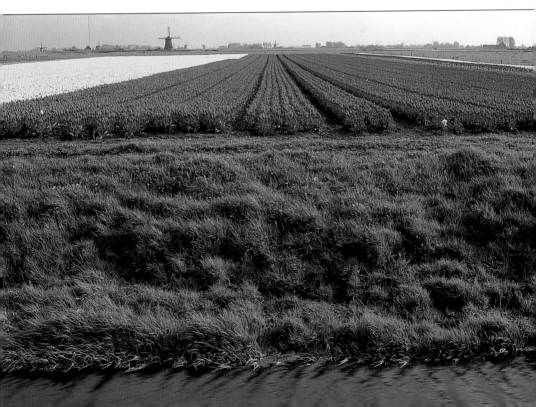

The burst of light from my camera's built-in electronic flash highlighted this Colorado thistle. The illumination from the flash also increased the contrast between the flower and the background, rendering it dark. Here, I used my Olympus IS-1 camera its built-in 35–70 zoom lens. The exposure was 1/60 sec. at f/11 on Ektachrome 100 Plus EPP film.

When determining which film to shoot, professional photographers also take into account whether their images will be used for publication or for fine prints. As such, professionals often shoot several films simultaneously in different camera bodies in order to be prepared for all contingencies. For example, Kodachrome produces a rich Cibachrome print, but it doesn't reproduce as well in magazines as Fujichrome and Ektachrome do.

Check the technical information included in the captions to see which film was used for each image. This will enable you to see what you can achieve by making informed film choices. Then be sure to experiment to determine which film gives you the results you prefer.

ELECTRONIC FLASH

Since most flower photography is done outdoors, amateur photographers rarely associate it with the use of an electronic flash unit. But in fact, flash can greatly increase your control of natural light and help you cor-

rect some common problems. For example, on sunny days, flash can reduce the amount of contrast in a scene by illuminating shadows, thereby better balancing the light in your composition. The trick is to blend the artificial light of the flash with the existing available light, so that the result is soft and natural. (Chapter 7 discusses such closeup-photography techniques in detail.)

A bright burst of light from a flash unit can also increase the amount of contrast between foreground flowers and their backdrop, creating a dark, dramatic frame for your subjects. In addition, flash can add sparkle to flowers shot on a dull day. Flash is also invaluable in terms of stopping motion due to wind and is quite effective for increasing depth of field in closeup photographs.

To make the best use of a flash unit, you should be able to control both its power output and direction. Ideally, your flash unit should be dedicated—that is, electronically linked—to your camera's metering system. Check the instruction manual that came with your flash unit to see if this is the kind you have. If you're buying a new flash unit, be sure that it is a dedicated model (most new models are).

In addition, the flash unit should have a variable power control. This feature will enable you to reduce the power output if you want less than the maximum level of illumination your particular unit produces. Such "fill flash" lets you create the most natural effects with artificial light. If you're working with a strong flash that pumps out too much light and has no power control, you may need to cover the flash unit with a handkerchief or white tissue paper in order to reduce both its power and the resulting glare. You can, of course, improvise until you find something that will do the job. (See the Appendix for a test to guide you in controlling light output for fill-in-flash effects.) This requires experimentation and careful record keeping.

The illumination from the electronic flash unit mounted on my camera brightened the foliage and fallen cherry-blossom petals. The burst of light also sharply delineated their shapes. Working in Holland with my Olympus IS-3, its built-in 35–180 zoom lens, and my Olympus G40 flash, I exposed for 1/60 sec. at f/11 on Fujichrome 100 RD film.

You should be able to fire your flash off your camera, either by holding the unit in your hand or mounting it on a specially designed bracket that you can buy in camera shops. The worst place for an electronic flash unit is on the camera's hotshoe; this is particularly true for closeup photography. The hotshoe is a built-in mounting device, usually on top of the camera, that the flash unit attaches to for a direct hookup to the firing mechanism. Removing the flash from the hotshoe gives you the opportunity to simulate backlighting and sidelighting, which are more flattering to flowers than frontlighting is.

Another flash option is to use circular ring-flash units. These mount directly on the lens. The light they produce is more uniform than that of a standard flash unit, but it is flat and bright. Furthermore, you can't direct the illumination they give off in order to simulate backlighting or sidelighting. As a result, ring-flash units are of limited use for aesthetic light effects.

ACCESSORIES

There is no end to the gadgets, paraphernalia, and accessories to tempt the determined flower photographer. Some items are more vital than others. You should give some serious thought to investing in the following accessories; they are the most essential and useful.

A sturdy, stable tripod is the most important accessory for effective flower photography. It enables you to compose carefully and precisely, and to maintain any position—no matter how high, low, or awkward—through several exposures. Because you can use slow shutter speeds when your camera is mounted on a tripod, you can keep your aperture small for greater depth of field and maximum sharpness. This option is important for all flower photographs, but it is especially critical for closeups.

Choose a tripod that has an interchangeable short centerpost and legs that spread very far apart, such as the Gitzo and Bogen models. The wider the angle—up to 90 degrees from the centerpost—the easier it is for you to work close to the ground and position the tripod securely on even the most rugged terrain. Look for a model with a ball-joint head that connects the camera to the tripod. One that maneuvers easily and locks with a single turn makes using a tripod a pleasure.

A good lens shade prevents extraneous light from entering the camera and degrading the color saturation or apparent sharpness of your image.

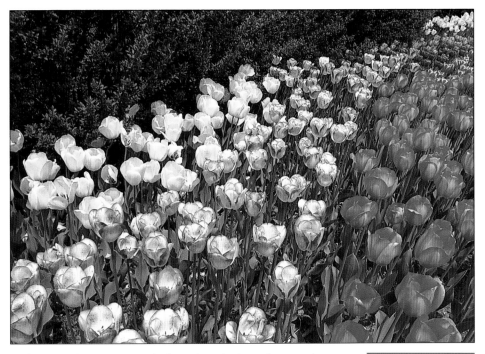

Each lens needs its own properly fitting lens shade, so that it works properly without cutting off the corners of your image. If you have a filter on your lens, especially a thick polarizer (see below), check through the viewfinder to be sure that the lens shade isn't visible. If it is, switch to a shorter lens shade. A thick rubber shade is also excellent protection against rain, snow, fingerprints, and accidental damage that may be caused by a bump or fall.

You'll want to have a cover for your equipment because flowers are attractive subjects even in the rain. To protect your camera and lens, bring a plastic sheet, tarp, or poncho with you, or simply carry some plastic bags that are large enough to cover your camera and lens. Be sure to keep your lens covered when you aren't shooting. If your camera and/or lens gets wet nonetheless, dry off any water spots with a small towel as soon as you notice them.

A polarizer eliminates or reduces glare and reflections on foliage, petals, water, and other surfaces. As a result, it deepens colors and turns the sky a dramatic blue. To get the exact result you want, rotate the polarizer and watch what happens through your viewfinder as you turn it.

A polarizer has the greatest effect when it is at a 90-degree angle to the sun, and the least when it faces directly into or away from the sun. For autofocus cameras, use a circular-type polarizer, not a linear model, which interferes with automatic focusing. Bring your camera and lenses with you when you go to buy polarizers, so you can check that they fit properly and don't cause the partial obscuring of corners called vignetting.

A gray card is the 18-percent standard measure of exposure under all lighting conditions. Keep it in your camera bag at all times. This way, it will be available whenever you can't easily determine exposure because a subject is too far away or contains different color intensities. Just be sure to place the gray card in the same light as your subject before taking a meter reading; otherwise, the reading won't be accurate.

A sturdy tripod was a must for the precise framing and the slow shutter speed needed for this shot of a tulip garden at The New York Botanical Garden. Here, I used my Olympus OM-3 and Zuiko 24mm lens on a tripod. The exposure was f/16 for 1/30 sec. on Kodachrome 64.

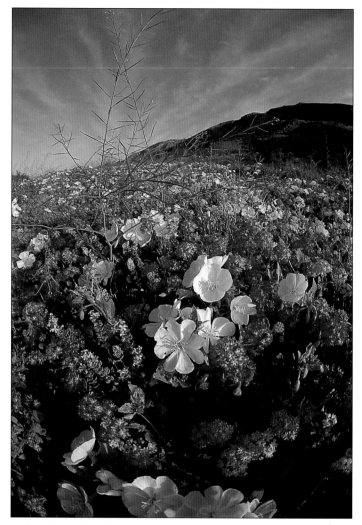

Finally, a cable release is a smart purchase because it can improve your images. It lets you trigger the shutter without touching your camera. This accessory reduces camera shake and comes in handy when you're making long exposures.

In addition to buying those absolutely necessary accessories, you might want to contemplate purchasing the following useful but not absolutely essential items for your flower photography. First, extension tubes are compact and affordable accessories, and they provide the most practical way to shoot closeups without using macro lenses. Extension tubes come in kits of three or four and can be combined to produce larger-than-life-size images on film. Once you place the extension tubes between the lens and the camera body, they're automatically coupled to your camera's metering system.

Closeup lenses are inexpensive alternatives to macro lenses. These lenses are often called magnifying filters because they screw onto the front of the lens just like filters. Closeup lenses are sold in kits of +1, +2, and +4 diopters—the higher the number, the greater the magnification

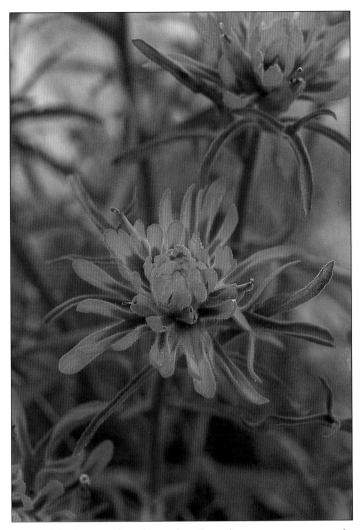

When shooting in sandy environments like the Mojave Desert, use a 1B skylight or 81A warming filter to protect your lens from windblown particles. Incidentally, these filters add a bit of color to your subject. For this shot of Indian paintbrush in Death Valley, California, I used my Olympus OM-4T and my Zuiko 90mm macro lens mounted on a tripod. I exposed Fujichrome Velvia for 1/30 sec. at f/16.

power of the lens—and can be combined to achieve a maximum magnification of +7. When used with telephoto lenses, closeup lenses produce a soft focus, which many flowers photographers like. Keep in mind, though, that these lenses are somewhat less sharp than macro lenses, particularly at the edges.

All lenses should have protective filters on them. To guard against dust, scratches, and abrasions, use a 1A or 1B skylight filter or an 81A warming filter. When you shoot outdoors, these slightly pink filters counteract light reflected from the sky, which often gives a bluish cast to photographs taken in bright midday sun or in deep shade. Naturally, however, you should take these filters off when you are about to photograph blue, mauve, or purple flowers.

Color-correction (CC) filters can enhance the color of subjects, especially in closeups in which one color dominates. A CC filter deepens its complementary color. For example, a green CC filter enriches magenta, and a magenta CC filter enhances green; for yellow, use a purple CC filter, and so on (refer to the color wheel). Be aware, however, blue flowers

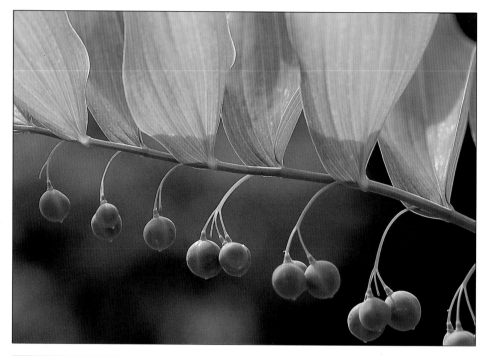

are an exception because they tend to photograph pink, especially on bright days. To achieve true blue, use a 10CC cyan filter, or wait for a hazy or dull day to photograph blue subjects.

CC filters come in different intensities, which are indicated by their numbers. The higher the number of the filter, the deeper its color intensity is. Don't rely solely on this numbering system. You should make your selections after seeing the actual filters—unless you're simply replacing one. Professional photographers buy CC filters in a series, and when they shoot, choose the one that will give the desired degree of enhancement. A final point about CC filters: remember that a colored filter on your lens affects the color of the background scene as well as that of the floral subject.

Diffusion filters produce a soft-focus effect that gives gardens, scenics, still lifes, and closeups a misty, romantic aura. They come in various degrees of diffusion. These filters work best in soft sidelighting and backlighting conditions, especially when the colors are muted. Diffusion filters are excellent choices for creating pastels, too.

Graduated filters are neutral-density (ND) filters that gradually go from clear to dark gray. ND filters don't affect the color of the subject. Their purpose is to reduce contrast in an image, primarily between the land and the sky. For example, a field of flowers at sunrise may be considerably less bright than the sky. When properly positioned on the lens, a graduated filter will darken the sky to unify the illumination.

The simplest way to increase the illumination on flowers is by using a reflective device, which you angle to the desired position. You can buy ready-made reflectors or make your own out of a piece of white cardboard, foamcore, or packing material. Students have improvised reflectors from books, briefcases, sheets of paper—anything that can direct light onto the subject. If you want the illumination to be quite intense, use a highly reflective surface, such as aluminum foil wrapped around

cardboard. Another advantage of using reflectors: they are light enough to carry with you when you go out to photograph.

For special shooting situations, you might want to consider the following accessories. If your tripod can't get low enough for closeups of flowers that hug the ground, a universal clamp will enable you to attach your camera to a tripod leg or some other convenient object. The Bogen universal clamp is a great choice because it is quite easy to attach and maneuver, and it stays put.

A quick-release gadget, which you place on your tripod head, permits you to detach one camera body and attach another with a simple motion. Finally, a right-angle device placed on the camera viewfinder works like a periscope and enables you to view your subject at a 90-degree angle. This allows you to position your camera close to the ground and still work comfortably, without lying on the ground.

Although many accessories are discussed here, you should buy only what you really need and will use at first. As you continue to hone your technique, you can add to your collection. Be sure to take along only what you're comfortable carrying when you go out to shoot. Nothing spoils a photography outing more quickly than a burdensome bag full of gear.

By attaching a +2 screw-on closeup lens to a tele-photo lens, I was able to create a soft-focus effect. I made this shot of an anemone in Jerusalem with my Nikon F2 camera and my Nikkor 200mm lens mounted on a tripod. I exposed for 1/125 sec. at f/4 on Kodachrome 64.

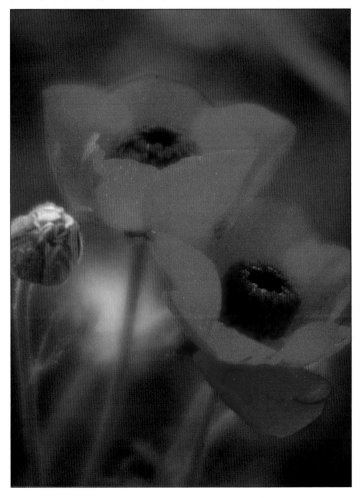

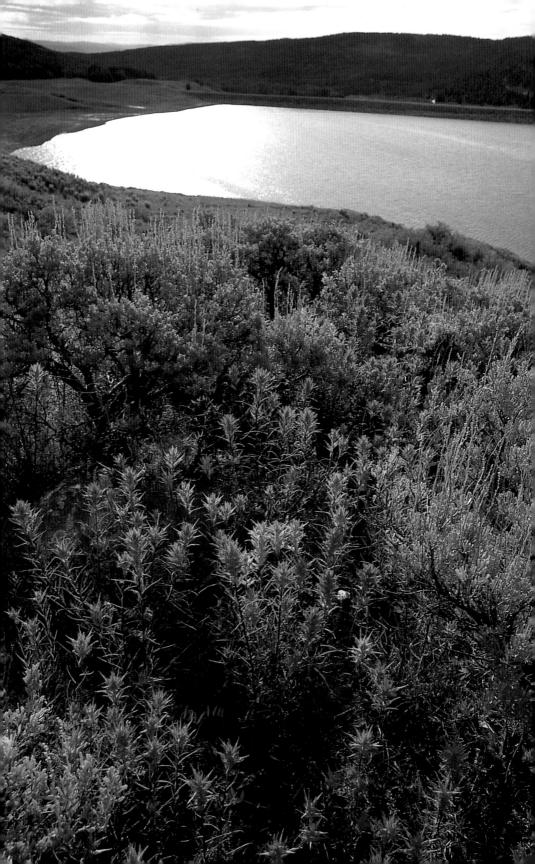

Shooting from a Distance

I came across this spectacular scene in Colorado. I used my camera's 35–180mm zoom lens so that the final image would encompass both the Indian paintbrush in the foreground and the Rocky Mountain landscape behind the flowers. Shooting with my Olympus IS-3 mounted on a tripod, I exposed Fujichrome 100 RD film for 1/125 sec. at f/11.

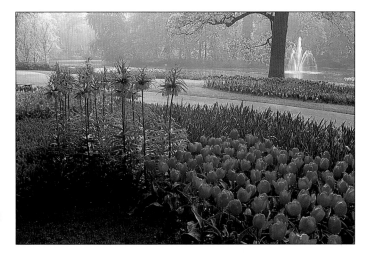

I photographed this panoramic view of a misty garden setting in Holland with my Zuiko 35mm wide-angle lens and my Olympus OM-4T mounted on a tripod at chest height. I exposed these tulips and emperor plants at f/16 for 1/15 sec. on Fujichrome 100 RD film.

Flower photographers face many decisions regarding their picture-taking. One of the first choices they make—before selecting a lens, f-stop, or shutter speed—involves the scope of the image. This is based on the distance between the floral subject and the camera. For the sake of convenience, you can classify the various options into three general categories: panoramas and overviews from a distance of more than 30 feet, vignettes from a middle distance of 30 feet down to 1 foot (see Chapter 6), and closeups from a distance of less than 1 foot (see Chapter 7).

An ultrawide-angle lens produced both close-focusing and extensive sharpness in this picture of verbena and evening primroses. The lens' broad perspective also included a hint of the Anza Borego landscape. I photographed these desert wildflowers with my Olympus OM-4T and my Zuiko 18mm wide-angle lens mounted on a tripod. The exposure was 1/60 sec. at f/16 on Fujichrome Velvia.

Flower photographers often overlook panoramas and overviews because they tend to become entranced with individual floral specimens. Although it doesn't matter if you shoot individual flowers first or panoramas and scenics first when you find a promising location, you should be alert to opportunities for shooting overview pictures as soon as you arrive on the scene—particularly if you can't go back to the spot.

The great advantage of panoramas is that they capture flowers in their natural setting. Too often, flower photographs give little or no indication of where they were shot. The images may be marvelous portrayals of the subjects at hand, but they tend to become indistinguishable from one another. After all, does a lupine in one location look all that different from a lupine in another? Including the flower's setting adds a powerful dimension to your photographs; it is similar to the difference between a studio portrait of a person and a family group portrait taken in that person's home. Both pictures have their place and their value. Simply be sure that you don't miss the chance to show the grand vistas in which flowers are often found.

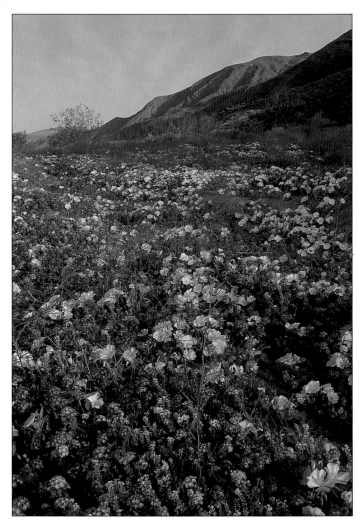

PANORAMAS AND SCENICS

If you are one of these photographers and have neglected to portray flowers in the broad context of their setting, make a point of trying to vividly document entire scenes. These images are useful and informative. Without them, viewers can't tell where a particular flower grew. A subject's setting and context add an interesting dimension to your flower photography.

Your goal here is to make such images aesthetically appealing. Specifically, the challenge in shooting the panoramas that contain flowers is to do justice to them, as well as to their setting. Effectively integrating these two elements requires some technical know-how and looking carefully at the scene.

Begin by finding a perspective with compositional interest. If you're shooting in a garden or field, this element could be a path or stream that leads the eye from one point of the frame to another. The lines of nearby trees or the shapes of rocks and hillsides can also add graphic vitality to your image. Don't get so carried away by the bright colors of flowers that you forget to organize your photograph.

Once you've settled on a promising perspective, use a lens in the 28–50mm range in order to encompass the broadest vista containing flowers. Wide-angle lenses are designed to focus at a close distance and at the same time render considerable depth of field and a sweeping perspective. As such, these lenses enable you to shoot flowers closeup, as well as to include their surroundings.

Your next step is to concentrate on sharpness. Lenses with focal lengths in the standard to wide-angle range will provide enough depth of field to produce sharpness throughout your image—unless you plan to move as close as 1 foot from your foreground subjects. If your nearest subject is more than 30 feet away from you, simply focus on infinity; this

The beautifully illuminated farmhouse and dark hills effectively complement this lavender field in France. To photograph this charming Provençal setting, I used my Olympus OM-2S, my Zuiko 50mm lens, and a tripod. I exposed Kodachrome 64 for 1/125 sec. at f/8.

should make the entire image sharp. If, on the other hand, your nearest subject is fewer than 30 feet away from you, focus on a point that is between one-third and one-half of the way from the lower edge of your frame. This will maximize depth of field throughout the image.

For greatest sharpness, use the smallest aperture feasible for the exposure you need. Be sure to take into account any blurring that may result from the shutter speed you need to use. The impact of wind and motion is less of a problem in scenics than it is in pictures taken at close range or with a telephoto lens. Still, you should use a shutter speed of at least 1/60 sec. in order to reduce unwanted blurring.

INTEGRATING FOREGROUND AND BACKGROUND

Floral panoramas often demand that you integrate the foreground and background areas in a scene, successfully transforming a three-dimensional world into a two-dimensional medium. Visual artists meet this challenge in two opposite ways, each yielding fascinating and original results. One approach is to fool the eye by incorporating visual cues that suggest a third dimension. Objects that get smaller in the distance, such as a row of flowers or trees, and converging lines convey a sense of depth despite the flatness of the picture plane. The foreground and background become a flowing continuum in such images, and they contain a palpable sense of real space. Lenses in the 24–50mm range best achieve this effect.

The other approach is to emphasize the flat quality of a photograph by recording near and far components as if they were on the same plane. Here, the foreground and background appear as horizontal bands stacked one above the other, compressing space. The distance between them seems to have disappeared. Lenses in the 100–200mm range help create this sense of unreality or optical illusion. Finally, you can combine aspects of both approaches in a single shot for the most unusual results.

Whichever approach you choose, your image must be sharp throughout in order to represent both the flowers and their setting fairly. This requires focusing accurately and using the smallest aperture possible to produce the best exposure. Mounting your camera on a tripod also helps, especially when you're working with telephoto lenses.

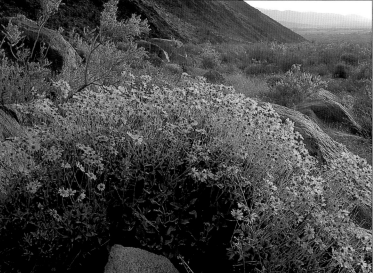

Visual cues, such as the large mass of brittlebrush in the foreground and the hazy, small hills in the distance, suggest a third dimension in this desert landscape. Shooting in California's Anza Borego State Park, I mounted my Olympus OM-4T and Zuiko 35mm wide-angle lens on a tripod. I then exposed for 1/15 sec. at f/11 on Fujichrome Velvia.

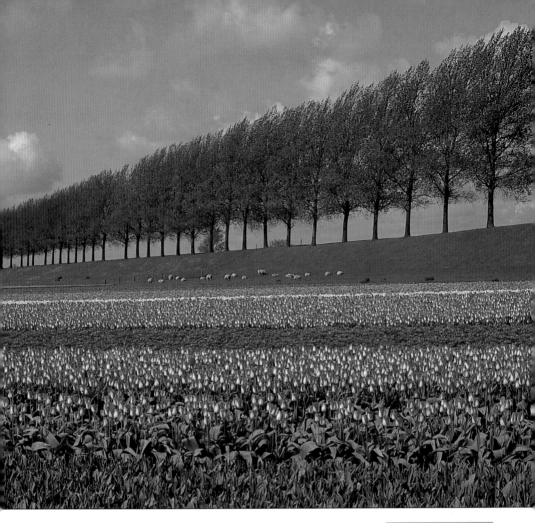

SLICE OF THE SCENE

When you're photographing flowers from a distance of at least 10 feet, you have the chance to create another visual effect that your eye can never see, a virtual "slice of the scene." Here, only a thin cross section of the scene is in sharp focus; the areas in front of and behind that slice are rendered deliberately out of focus.

To capture this small segment of the scene, use a telephoto lens set at its widest aperture. Keeping the lens wide open reduces depth of field, severely limiting the area of sharpness to create the slice of the scene. This aperture setting also permits you to see through your viewfinder the exact extent of sharpness and blurring that will appear in the final image. In addition, a wide-open aperture enables you to use a fast shutter speed, which is a necessity when you're shooting with long, heavy lenses.

Keep in mind that the slice-of-the-scene effect is reduced the farther away you are from your subject and the longer the lens you're using is. This is because as you move toward a focal point at infinity, you increase depth of field. Experiment with this technique at different distances between 10 and 30 feet, using a lens in the 200–300mm range. Doing this will help you learn what effects you'll get at various distances; as a result, you'll be able to make informed decisions in the future.

When I came across this scene in Holland, I decided to flatten the space between the tulip field in the foreground and the row of trees in the background. To achieve this unusual scenic, I mounted my Olympus IS-3 and my Zuiko 50-250mm lens set at 150mm on a tripod. The exposure was 1/125 sec. at f/8 on Fujichrome 100 RD film.

From a camera-to-subject distance of 50
feet, my Zuiko 180mm telephoto lens con-
centrated the poppies in this olive grove
in Israel. This long lens turned the flowers
into thick slices of red that complement the
dark tree trunks. For this shot, I used my
Olympus OM-2S mounted on a tripod.
The exposure was 1/250 sec. at f/5.6
on Kodachrome 64.

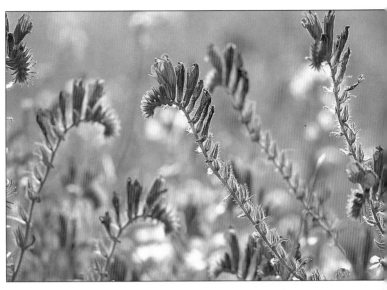

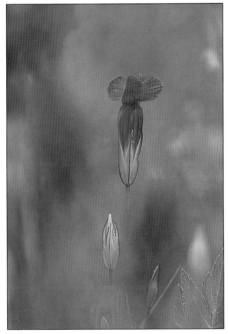

A powerful telephoto lens at its widest aperture setting captured a slice of this desert wildflower field in Israel. Working from a distance of 10 feet, I used my Olympus OM-2S and Zuiko 180mm lens mounted on a tripod. I shot this cluster of echium bugloss, a member of the borage family, on Fujichrome 100 RD film, exposing for 1/500 sec. at f/2.8.

In order to isolate one gentian in this Colorado bog from a distance of several inches, I needed to focus carefully. With my Zuiko 90mm macro lens set at its widest aperture, both the foreground and background were thrown out of focus. To capture this single wildflower, I mounted my Olympus OM-4T on a tripod and exposed Fujichrome 50 RF film for 1/125 sec. at f/2.8.

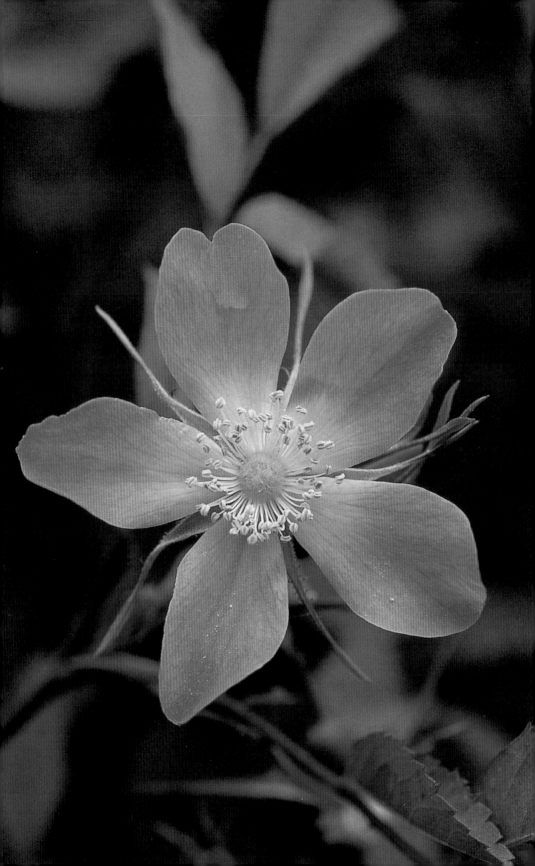

CHAPTER 6

Floral Vignettes

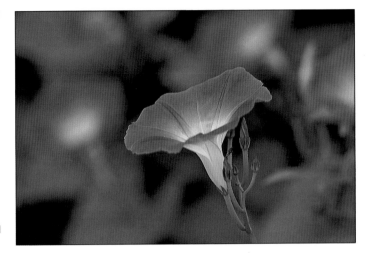

While preparing to photograph this rose in Maine, I realized that I needed to use fill-flash in order to create a successful image. By illuminating my floral subject this way, I was able to increase the contrast in the scene, thereby obscuring a busy, distracting background. I mounted my Olympus OM-4T and my Zuiko 90mm macro lens on a tripod and exposed Fujichrome 100 RD film for 1/125 sec. at f/5.6.

Careful framing enabled me to set these morning glories—one sharp, the others partially blurred with a relatively shallow depth of field—apart from their surroundings. I made this shot in a private garden in New York using my Olympus OM-3, my Zuiko 90mm macro lens, and a tripod. The exposure was 1/60 sec. at f/4 on Kodachrome 64.

Floral vignettes attempt to portray a more limited and defined space than panoramas and overviews do. Instead of capturing flowers within the context of some grand landscape or vital surroundings, vignettes separate floral subjects from all but their most immediate setting. As such, they aren't closeup portraits; these middle-distance shots taken from 15 feet or less include several flowers and a portion of the surroundings.

More personal and intimate than panoramas, less intense and dramatic than closeups, floral vignettes call upon a photographer's originality and subtlety. To succeed, these images must appear natural and artless, as if the viewers have stumbled upon something familiar yet usually overlooked. Floral vignettes evoke the feel of a location and capture its ordinariness with startling freshness. Picture a split-rail fence in a meadow of lupine or a woodland carpeted with pine needles—any subject that has a strong personal meaning as well as visual appeal. These photographs reconnect people emotionally with such archetypal scenes and preserve them for leisurely contemplation.

Photographic technique makes the difference between floral vignettes that work and those that don't. There is little room for error because the subject is clearly identifiable. Make sharpness a premium, particularly when surface texture adds to the realism of the vignette. Also, you must compose with the utmost care because every line and shape plays a starring role. In fact, every element counts to the extreme in vignettes, so don't leave anything to chance. Your floral vignettes should communicate your commitment, caring, and control.

SEPARATING THE SUBJECT FROM THE SETTING

Photographing vignettes calls for a shift in your imaginative focus. Since you want to concentrate on a group of flowers, you must find ways to make them appear dominant within the frame. Composition, the thoughtful arrangement of elements within the frame, takes on a much greater significance because you must balance several elements in a floral vignette. In addition, decisions about degrees of sharpness become critical to the way you represent the background.

Begin by thinking about your various lens options. Of course, you must remember that there is no single lens of choice, and that there are no hard-and-fast rules to follow. Select the lens that will portray the floral subject at the size you want from the distance and perspective you've

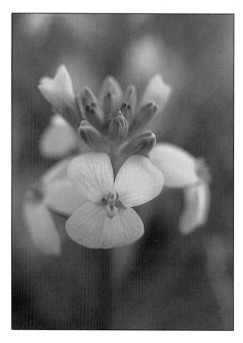

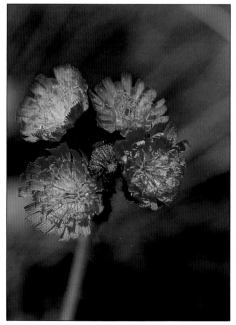

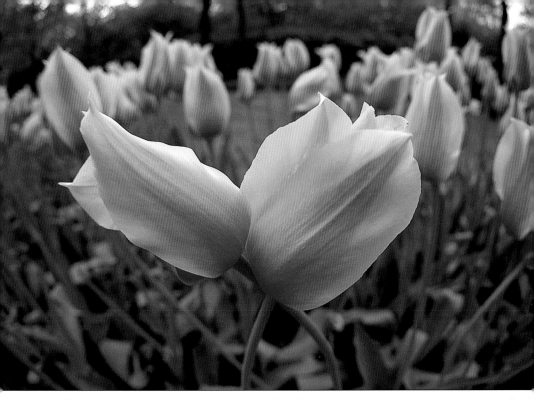

chosen. Base your lens choice on which one will produce the image you have in mind. As you think about this, keep in mind that the flowers must effectively fill the frame or they won't dominate the composition.

Next, consider the effect of the background, which can make the difference between a stunning photograph and a disappointing one. In vignettes, the background is likely to be quite distracting. All too often, otherwise fine photographs of flowers are ruined because trees, branches, plants, or light splotches mar the overall impact. Obviously, you can't afford to ignore backgrounds that detract from the beauty of flowers. In order to create successful vignettes, you must keep the background simple in any of the following ways.

The first method involves deliberately blurring any distracting elements. To throw an unwanted background completely out of focus, use a shallow depth of field. Your floral subject will then be the only sharp element in the frame. Working with telephoto and macro lenses is ideal for such selective focus because they render shallow depth of field.

Another way to simplify the background when shooting vignettes is to decrease depth of field by setting the lens aperture at wide open and moving in close to your subject. Then before you press the shutter, push the depth-of-field preview button in order to study the effect of the large lens opening on the background. Because the aperture is wide open, the background may appear to be out of focus when you look through the viewfinder; however, when the diaphragm closes down to the smaller aperture you preset, the background will be much sharper. But by using the preview button, which closes the diaphragm to the aperture setting you selected earlier, you can see the exact degree of sharpness in the background that will appear in the final image. This step is especially important if you're using a significantly smaller aperture.

Finally, before you press the shutter-release button, notice any bright spots of light in what little background may be visible. These will detract

A low perspective and an ultrawide-angle lens at its closest-focusing distance exaggerated the foreground tulips so much that they nearly fill the frame. The flowers just a little farther away seem to be pushed into the background. I made this shot in Holland with my Olympus OM-4T and my Zuiko 21mm wide-angle lens. I exposed Fujichrome 100 RD film for 1/125 sec. at f/8.

from your floral subject whether depth of field is shallow or extensive. Eliminate them by moving closer or changing your perspective; in turn, these strategies will prevent the background from being a disturbing element in the final image. Try setting the flowers against a uniform, preferably contrasting color. For example, shoot yellow daffodils up against a blue sky. Contrasting background colors can be either sharp or blurred. If finding a suitable background proves to be difficult or impossible, think of our ninth commandment, "never say done," and try again.

You can also simplify backgrounds in vignettes by taking advantage of contrasty available light. When shooting in these lighting conditions, set off brightly illuminated flowers against a shadow area in order to create a dark backdrop. If you can't find a deep enough shadow, use a flash to brighten the foreground flower and consequently darken the background. Another option is to try positioning yourself or a companion so that a shadow is cast behind the floral subject.

ISOLATING PART OF THE SCENE

Your floral vignettes will be most successful if you isolate your primary subject in order to have it fill the frame. This may require you to develop some new habits. Keep the following techniques and suggestions in mind when you shoot.

Move close to your subject. The biggest mistake photographers make is keeping a "safe" distance. This strategy only causes the flowers to appear too small and makes them uninteresting to look at. Get as close as you can, so the flowers that attracted your eye will be an eyeful in the image. If you can't get as close as you would like to because of physical obstructions, use a telephoto or zoom lens to magnify your subject.

When you find potential subjects, keep shooting. The same flowers will look very different from a variety of perspectives—above, below, behind, and so on. Continue to find new ways to photograph your subject, trying out anything you think will look good on film.

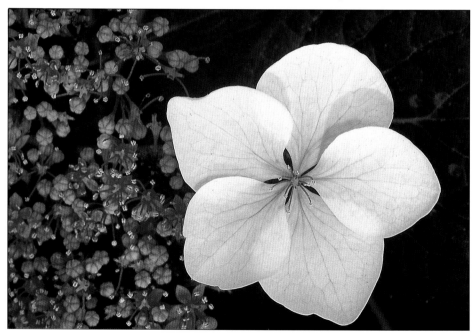

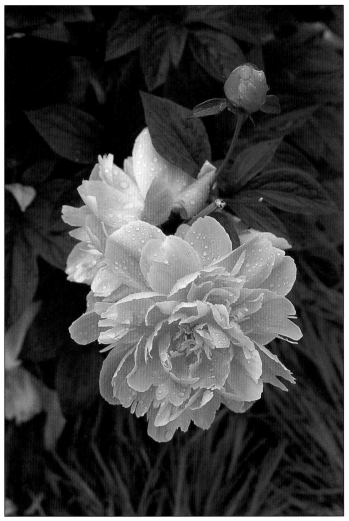

The dark green leaves of these peonies provide the contrast needed to make the flowers stand out. Shooting at The New York Botanical Garden, I mounted my Olympus OM-4T and my Zuiko 50mm macro lens on a tripod. I then exposed at f/8 for 1/15 sec. on Fujichrome 50 RF film.

Frame tightly. As you look through the lens at the whole scene, select those essentials that will convey your imagined interpretation of the flowers. Your next step is to fill the frame with those flowers. Their combined mass will then flood the picture with color from corner to corner.

When you want to isolate part of a scene, naturally you should downplay any visible background unless it contributes to the image. Use a shallow depth of field by opening the aperture to its widest setting in order to blur the background. Another option is to utilize shadows or dark shrubs, thereby providing a contrasting background.

COMPOSING FLORAL-GROUP PORTRAITS

Composing floral vignettes often means arranging a group òf flowers in a pleasing way. You'll find it easier to compose these floral-group portraits if you can forget for a moment that they are flowers and think of your subjects as abstractions based on color, shape, and line. The order and structure contributing to the overall design of your image will be based on these visual components.

Composing so that the purple gentian frames the evening primrose creates an evocative, colorful floral-group portrait. When I came across these flowers in Anza Borego State Park in Death Valley, California, I knew that together they would produce a strong image. Here, I used my Olympus OM-4T, my Zuiko 35mm wide-angle lens, and a tripod, and I exposed Fujichrome 100 RD film at f/11 for 1/8 sec.

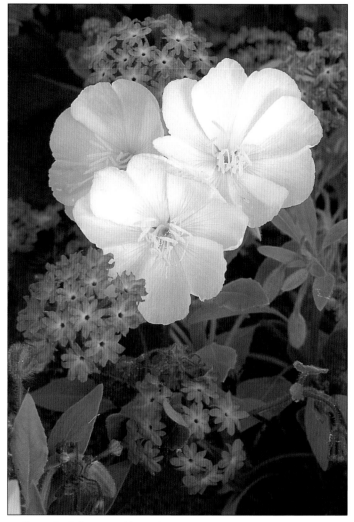

Keep the following additional tips in mind when you photograph will enable you to create strong floral-group portraits. First, avoid placing your subjects right in the middle of the picture. With few exceptions, the results are usually stilted and lack vitality or visual impact. Think of the overall design in terms of the balance two or more shapes, or the line that connects several flowers. Experiment with off-center arrangements, such as those produced by composing according to the Rule of Thirds grid. Here, you divide the picture into thirds horizontally and vertically, and then position the image's center of interest on one of points where the lines intersect.

You should also search for expressive combinations. A rose in full bloom is nicely set off against an unopened bud; the well-shaped cup of a tulip can be evocatively contrasted with one several days past its prime. Don't shy away from floral specimens that aren't at their peak: several flowers can be excellent subjects at various stages of their life cycle even though they may not look "picture perfect." Another option is to try shooting a bed of flowers to emphasize their graphic design.

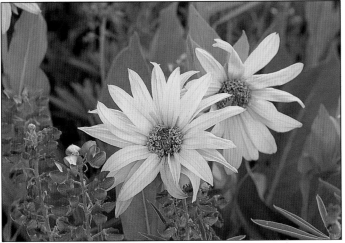

When composing this shot of sunflowers and lupine in Colorado, I moved slightly to the side. I wanted the main subjects to flow in a dynamic diagonal line. Shooting them full face would have produced a static horizontal line. For this picture, I mounted my Olympus OM-4T and Zuiko 90mm macro lens on a tripod. The exposure was 1/30 sec. at f/8 on Fujichrome Velvia.

By setting this cascading arrangement of Colorado wildflowers against nearby pine needles, I was able to achieve an image with graphic impact. This composition strategy created a design based on contrasting textures, colors, and shapes. Here, I used my Olympus IS-3 with its built-in 35–180mm zoom lens, and a tripod and exposed for 1/60 sec. at f/8 on Fujichrome Velvia.

Effective composition also calls for you to check all of the elements in the image, including the very edges of the frame, to be sure no unwanted intrusions appear. The better these visual elements interrelate in the picture, the more clearly your photograph will communicate to viewers. But the most important aspects of successful composition are being willing to experiment and keeping an open mind. Bending your knee, slightly changing your angle, or raising your camera a bit may alter the perspective, thereby transforming a dull composition into an exciting one.

ABSTRACT ARRANGEMENTS

Your flower photographs can become true flights of fancy if you let your imagination soar. View your subjects in the purest visual terms, as abstract elements rather than real-life objects. If you do this, they'll respond to your artistic vision.

For example, think of your floral subjects as blocks, bands, or swatches of color that wash across and around the canvas of the film frame. Play with bold and striking color combinations, like those of a field of red, yellow, and white tulips. You can also experiment with subtle, monochromatic combinations, like those of a bed of light pink roses. Your choice depends on the look and mood you want to create in your image.

Appreciate and take full advantage of the varied textures—coarse, fuzzy, spiny, velvety—you see in flowers and the foliage that surrounds them. Juxtapose different textures in the same flower bed to create a fascinating surface tension in your composition. Include rocks, paths, and other inanimate objects, such as fences, for added interest.

Have fun, too, with the watery reflections of flowers. For example, irises and water lilies grow in ponds and pools. And don't neglect the many other species that thrive along the banks. You can then go beyond the mirrored double image to more daring abstractions. Simply make the reflections themselves the sole or primary focus of the image.

Finally, if your floral subjects are blowing in the wind, try recording their swaying movements with a slow shutter speed. The blurs of motion that result leave a great deal to chance, but they illustrate the remarkable ways that the combination of a camera, a lens, and film can capture elusive moments of beauty that the naked human eye can never see.

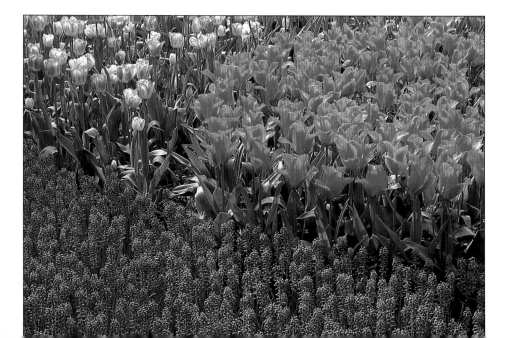

Floral Closeups

By shooting from a camera-to-subject distance of 10 inches with my Zuiko 90mm macro lens, I was able to make this shot of a small crocus a moderate closeup. The framing shows the shape and color of the flower's internal structures in sharp relief against the soft-focus petals. Working at The New York Botanical Garden with my Olympus OM-4T and my Zuiko 90mm macro lens mounted on a tripod, I exposed for 1/30 sec. at f/8 on Fujichrome 100 RD film.

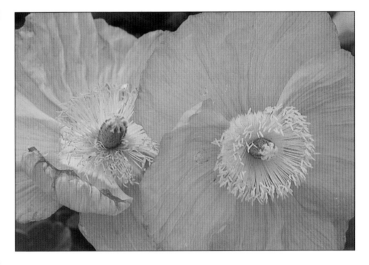

For this moderate closeup, I wanted the two poppies to fill the frame. Working in Arizona, I achieved this by photographing them from a camera-to-subject distance of just 6 inches. With my Olympus OM-4T and my Zuiko 50mm macro lens mounted on a tripod, I exposed Fujichrome 100 RD film for 1/30 sec. at f/8.

A photographer's first experiment with closeup equipment never fails to produce a moment of utter surprise and amazement. Familiar subjects suddenly become new and marvelous by virtue of the camera's ability to magnify what the human eye sees. Floral closeups take viewers on a fantastic journey into a flower's interior through which they can explore a myriad of tiny, exquisite structures.

Shooting from a distance of 8 inches, I decided that a floral closeup would best enable me to emphasize the radiating lines of the petals and the sharply contrasting colors of this zinnia. I made this shot at The New York Botanical Garden with my Olympus OM-4T and my Zuiko 90mm macro lens mounted on a tripod. The exposure was 1/125 sec. at f/11 on Fujichrome 100 RD film.

But to fully enjoy this magnificent odyssey, you must prepare yourself for the inevitable turbulence along the way. Closeups are among the most difficult and frustrating photographs to make. Just as they enlarge a flower, they also magnify any flaws in your technique or in the conditions you face. Small specks of bright light can become huge, blinding abstractions. Tiny movements can ruin the absolute sharpness that closeups demand. Also, imprecise focusing—exaggerated by shallow depth of field—can destroy an otherwise appealing image.

The best way to cope with these dangers is to relax and brace yourself with a great deal of patience. Producing outstanding closeups takes quite a while, too. You'll need more time to set everything up just so—your tripod, your flash unit, your polarizer, and your focusing ring. Then you'll spend long moments waiting for the light to change, for the breeze to stop, or for a shadow to appear behind your floral subject. You may shoot half a roll of film just to get a single, usable image. This is what closeup photography entails, and there is no point fighting it. Shooting floral closeups is truly an exercise in selfless devotion, but they truly are worth the effort.

MODERATE CLOSEUPS

Technically, moderate closeup images are one-tenth life-size or greater. In other words, the image on the film plane is at least one-tenth as large as it is in reality. Since 35mm film is approximately 1 1/2 inches wide, an area no more than 15 inches across would have to fill the frame in order for the resulting picture to be considered a closeup.

Macro lenses are best for moderate levels of magnification—from one-tenth to one-half life-size—but all lenses can work, provided you attach extension tubes or screw-on closeup lenses. Wide-angle lenses, however, are an exception. They would have to be as close as an inch from the flower in order for it to fill the frame, but this camera-to-subject distance would cause too much distortion.

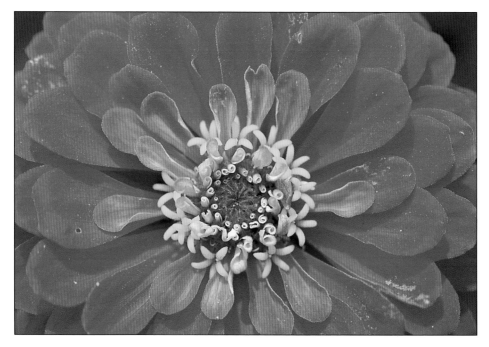

Because I wasn't able to get close to this coreopsis bud in Death Valley, California, I used a telephoto lens to create this moderate closeup. I mounted my Olympus OM-4T and my Zuiko 180mm telephoto lens fitted with a 25mm extension tube on a tripod, and I exposed Fujichrome Velvia for 1/125 at f/5.6.

When you compose moderate closeups, pay attention to the lines, shapes, and colors within each flower. Make the most of diagonals, curves, and radial patterns that, naturally, radiate out from the center. Emphasize the fascinating shape of the entire flower or its main parts, such as its petals, stamen, pistil, and anther. And be sure to fill the frame with the subtle tonalities that become visible in closeups.

Floral closeups require some special considerations. First, you must always use a tripod to prevent camera shake, which is exaggerated by magnification. A tripod also enables you to avoid having to hold the uncomfortable, contorted positions that closeups often require. These shooting positions can be quite challenging.

Imagine this typical flower-photography scenario. You spot a photogenic flower; however, the only way to successfully capture it on film is to shoot from a very low perspective. Because this requires your camera to be just 3 inches from the ground, you have to kneel down on rocks and twigs. Although your derrière is now sticking up in the air, you can look through your viewfinder as you compose, focus, and wait for the

wind to stop before you press the shutter. Of course, you're waving away nasty insects and assorted wildlife at the same time.

When shooting moderate closeups, you'll also want to maximize sharpness despite the reduced depth of field caused by working at short focal distances. Therefore, you should compose so that as many features as possible are parallel to the film plane. This will make focusing easier and will keep the image as sharp as possible. Determining exposure isn't a major concern with moderate closeups. Ordinarily, you're dealing with one color in a particular light, so all you have to do is take a closeup meter reading of your subject. Next, you simply use a small aperture. If movement due to wind is a problem, wait for the wind to stop, shoot at the turning point, or add illumination with a reflector or a flash unit.

EXTREME CLOSEUPS

Extreme closeups, which magnify your floral subject to more than one-half life-size, also magnify the challenges and problems that moderate closeups pose. More than technique, extreme closeups require a great deal of patience and persistence. To achieve such high magnification, you'll need extension tubes or bellows, which are placed between your camera body and a 50mm macro lens. Extension tubes are easier to use than bellows, range in length from 7mm to 25mm, and can be combined to further increase magnification. Bellows are simply bulky variations of extension tubes that produce the same effect.

A standard macro lens with extension tubes is the best choice for extreme closeups. However, if you can't get close enough to your subject using such a lens—approximately 8 inches, depending on the lens model, is the farthest working distance—try using your extension tubes with macro telephoto lenses. A 100mm macro lens, for example, provides the same size image as a 50mm macro lens, but at twice the distance. And a 200mm macro lens produces the same size image as a 50mm macro lens,

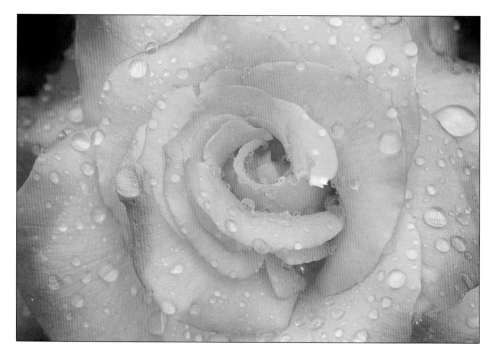

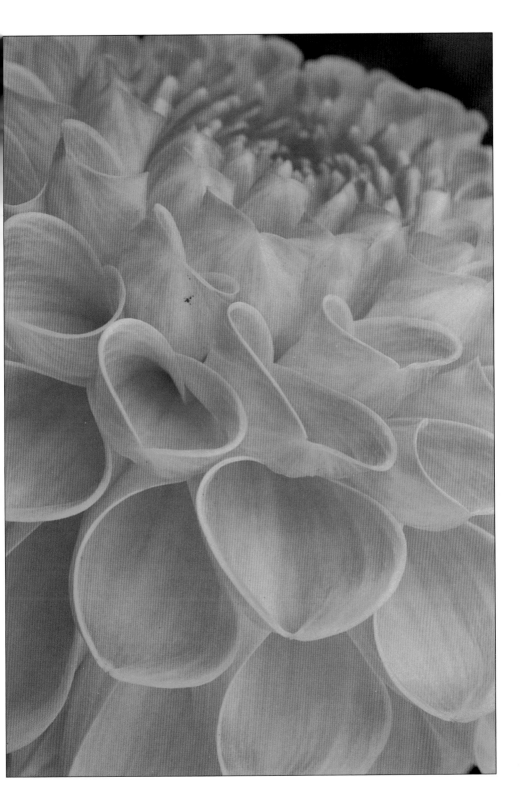

For this shot of a Texas poppy, I needed to supplement the available light with two Olympus T-20 flash units. I aimed one directly into the flower, and placed the other flash behind it for backlighting. Shooting with my Olympus OM-4T and my Zuiko 90mm macro lens with a 25mm extension tube mounted on a tripod, I exposed Kodachrome 64 for 1/60 sec. at f/22.

but this macro telephoto lens does so at four times the distance, which still isn't very far away when you're dealing with inches.

High magnifications make focusing critical. Using a tripod is an absolute must for extreme closeups. A specialty tripod made by Benbo also offers the greatest flexibility in terms of positioning the camera. The tripod's "bent-bolt" axis lets you mount the camera at any angle, and the whole mechanism locks with one turn of a large lever. This model is invaluable for extreme closeups because you can maneuver it very close to your subject.

In addition, a focusing rail or stage attached to your tripod will make small focusing adjustments more convenient because it permits you to easily move the entire camera-and-lens assembly closer to and farther away from your subject. A good rack-and-pinion stage works the same way, but it is more precise and can be locked at any point.

For accurate exposure, rely on your automatic-exposure settings, giving priority to small apertures for maximum sharpness. Bracket the shot by using your exposure-compensation dial. Be aware, however, that you may wind up with very long shutter speeds; these, in turn, may cause other problems, such as blurs due to movement. If your exposure time is more than one second or if conditions are windy, you should consider increasing the illumination via reflectors or an electronic flash unit so that you can use a faster shutter speed.

ADDING LIGHT

For stopping motion, achieving extreme sharpness, and maximizing depth of field in closeups, you'll find that an electronic flash unit is invaluable. The quick burst of bright light, which lasts no more than 1/600 sec., stops even the fastest movement regardless of your shutter speed. The additional illumination makes it possible for you to stop down the lens; the resulting very small apertures increase sharpness and produce extensive depth of field.

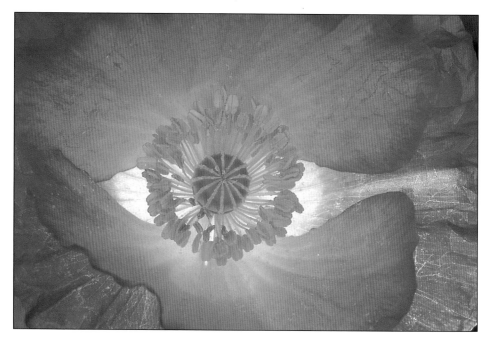

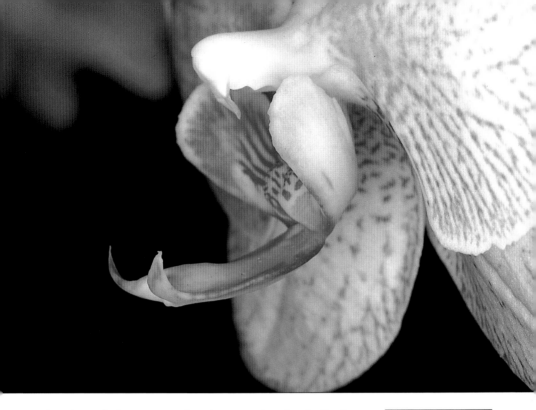

An ordinary flash unit mounted on the camera is useless for floral closeups because it produces a harsh, flat, contrasty light. Furthermore, the flash is aimed above the flower and won't illuminate it properly. The only kind of flash unit worth serious consideration is one that mounts directly onto the lens, not on a hotshoe, such as a ring-light flash.

However, you can fire an ordinary electronic flash unit off the camera using a TTL extension sync cord. This handy accessory permits you to fire the flash at a convenient angle for interesting possibilities. Position the flash above the camera and at a diagonal for a studio modeling effect. You can also experiment with variations on backlighting and sidelighting. Just be sure that the flash unit isn't visible in the viewfinder.

Getting the right exposure in closeup flash shots is rather difficult, so many photographers are discouraged from trying the technique. The reason is that the automatic-exposure calibrations for flash shots are based on distances far greater than those used for closeups. Even with variable power and off-the-film metering, most electronic flash outputs are too bright for proper closeup exposure.

However, a simple test can guide all future closeup photography you do with the same flash unit (see the Appendix). In essence, the test involves covering the flash unit with successive layers of lens tissue in order to reduce the brightness of the flash. Once you have the results of your test, you'll know exactly how to achieve proper exposure for full flash and for fill-in flash in your closeup photography.

The key to successfully integrating added light is to keep the flash power low enough so that it matches—but doesn't overwhelm—the available light. Controlling the light output also affects the extent to which it contrasts with the background. The greater the amount of contrast, the darker the backdrop will become.

In order to effectively capture this orchid, I used my Olympus T-20 flash unit to add more light. I then mounted my Olympus OM-4 and my Zuiko 80mm macro lens on a tripod. The exposure was 1/60 sec. at f/22 on Kodachrome 64.

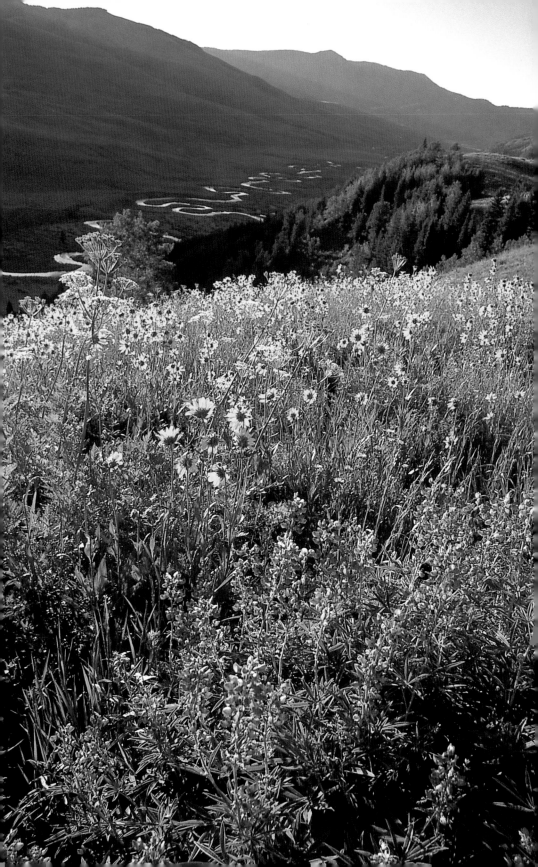

CHAPTER 8

Flowers in Their Settings

A medium-wide-angle lens effectively recorded both the foreground wild sunflowers and lupines on this mountain meadow and their setting near Crested Butte, Colorado. After mounting my Olympus OM-4T and my Zuiko 35mm lens on a tripod, I exposed Fujichrome 100 RD film at f/16 for 1/60 sec.

Wetlands prevented me from getting close to the gentians in this Colorado bog, so I had to use my Zuiko 50-250mm zoom lens in order to create a floral impression. Shooting with my Olympus OM-4T mounted on a tripod, I exposed Ektachrome 64 Professional EPX film for 1/125 sec. at f/5.6.

T he more you know about the natural environments in which flowers grow, the more accurate your expectations about photographing them will be and the better prepared you'll be for the special conditions you may face. First of all, you need to become informed about the kinds of wildflowers you'll encounter and their blooming season. The bloom may last only one day—which isn't encouraging if you have to travel a long way to your destination—or, more typically, a week to a month.

This image of Maine lupines could be taken only at 5:30 in the morning in order to capture the soft backlighting of sunrise that makes these wildflowers glow. I made this shot with my Olympus OM-4T and my Zuiko 50–250mm zoom lens set at 200mm, which I'd mounted on a tripod. The exposure was 1/125 sec. at f/4 on Fujichrome 100 RD film.

If you hope to shoot a particular flower, learn in advance where you are likely to find it, such as a meadow, desert, coastal area, or forest. You can get this information at libraries; those associated with botanical gardens are particularly good resources. Get specific directions or a map so that you won't be frustrated in your search.

In addition, you have to adapt your choice of film to each environment. You also need to be flexible when you select the filters and other accessories that will help you cope with the lighting conditions and other characteristics of the area. Finally, you must be prepared to take care of your equipment differently in each type of location.

MEADOWS

Meadows, with their expansive, wide-open spaces, offer photographers a profusion of wildflowers over an extended growing season, from early spring into fall. Naturally, the season lasts longest at the lower elevations. Each region of the United States has distinctive wildflowers, which

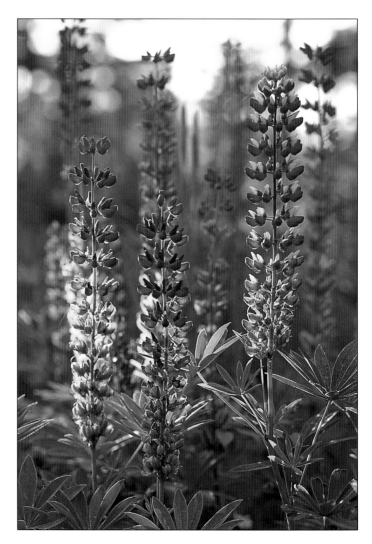

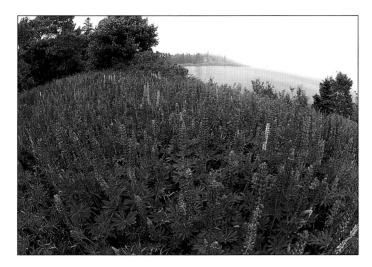

I photographed these lupines in Maine with my Olympus OM-4T and my Zuiko 35–70mm lens mounted on a tripod. The exposure was 1/60 sec. at f/11 on Fujichrome 100 RD film.

photograph well in combination with typical features of the area. You can, for example, shoot the bluebonnets of Texas surrounding local barns and stables, show the lupines of Maine abutting coastal waters, and capture fireweed against a Rocky Mountains backdrop.

With their unobstructed vistas, meadows also offer the widest variety of photographic opportunities, from broad floral landscapes to very detailed closeups. For floral scenics, try using your wide-angle lens to emphasize foreground subjects while maintaining the sweep of the land in the background. Look carefully at the sky: Use it only if it adds value to your image—either as a form in your composition or because the clouds provide an interesting counterpoint to the landscape. Remember to maximize sharpness with a small aperture and to focus one-third of the way into the frame.

Because many flowers grow so close together in meadows, you should experiment with vignettes that juxtapose them in graphic ways. Let your imagination run free as you look through your lens, scanning the scene and discovering arrangements that please your eye. The possibilities are seemingly unlimited. A meadow is also a great place to whip out your telephoto lens. With it, you can shoot some evocative, abstract images that compress space, portray a slice of the scene, and capture compelling arrangements of color.

When photographing in a meadow, don't be daunted if the wind is blowing, which it well may. Take the opportunity to experiment with slow shutter speeds in order to add another dimension to your flower photographs. Shutter speeds between 1/8 sec. and 1 sec. will enable you to record the swaying and tossing motions of flowers and grasses. The resulting images will contain unpredictable yet fascinating blurs. However, when you shoot closeups in a meadow on a breezy day, you must counteract the effects of the wind by using the fastest possible shutter speed and, if necessary, adding light with a flash unit or reflector. Of course, another option is to photograph early in the day before the wind picks up.

Light is most dramatic at the extremes of the day, so take advantage of it by shooting at sunrise and just before sunset. Even on overcast days, light tends to be bright all day long in meadows, often producing glare on the foliage and casting shadows within a meadow. Use a polarizer in order to eliminate this unwanted glare and to transform shadows into an

interesting foil for your floral subjects; the resulting contrast gives the field of flowers textural richness. If you underexpose to saturate the colors of the flowers, the shadows will turn black, adding to the apparent sharpness in the image.

And if you are truly ambitious, try photographing in meadows during the late fall and winter. At these times of the year, the flowers that were once bursting with color are muted and dried. But they still make wonderful subjects: their brittle shapes stand in sharp relief against the autumn sky or the snow.

WETLANDS AND COASTAL AREAS

The areas near bodies of water can either be very rich in vegetation and flowers or can have very sparse plantings. Look for wild roses on sandy shores, ground-hugging succulents along rocky cliffs, dense stands of irises along lake shores, and water lilies in ponds or pools. Blooms in wetlands and coastal areas are most profuse during the late spring and the summer, from May through August.

114

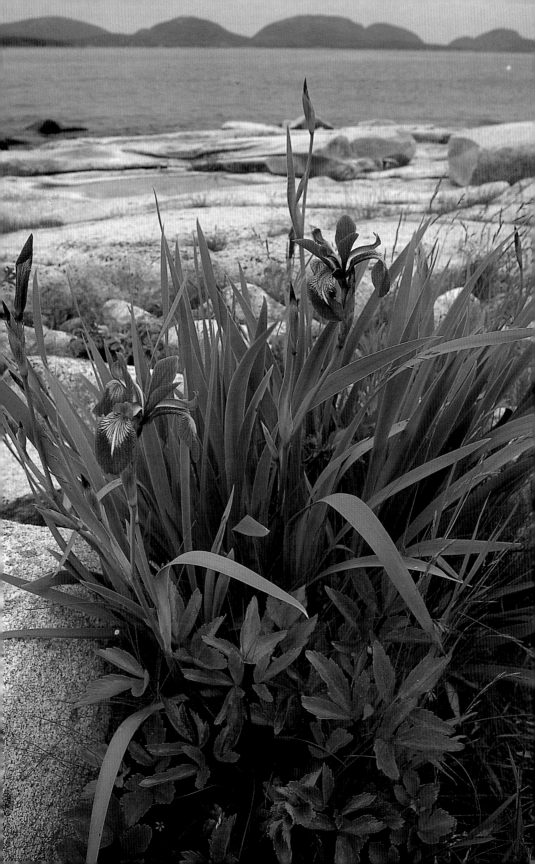

A clearing in this Colorado aspen grove provided enough space and light for me to create an intimate shot of this landscape. Here, I was able to integrate the white Indian paintbrush in the foreground with the distinctive trees in the background. I mounted my Olympus OM-4T and my Zuiko 35–70mm lens on a tripod and then exposed for 1/30 sec. at f/11 on Fujichrome 100 RD film.

I came across this mariposa tulip in Colorado in windy, dimly illuminated conditions. To achieve a successful closeup image of this flower, I needed to hold an electronic flash off the camera so that the burst of light would strike the tulip at the right angle. Shooting with my Olympus IS-2 and a closeup lens mounted on a tripod, I exposed at f/11 for 1/60 sec. on Fujichrome Velvia.

Since coastal areas can be windy, you need to take along some fast film. This will permit you to use a fast shutter speed to freeze motion when you shoot. You also have to carefully frame your shots in order to minimize glare from the water, sun, or sand. For example, you might want to let the flowers dominate the composition and aim away from the water rather than toward it. A polarizer can help reduce any remaining glare from water and other reflective surfaces that can't be eliminated.

You should also take advantage of shooting in coastal areas and wetlands on foggy or misty days. Under the overcast illumination characteristic of fog and mist, you can capture the rich colors of flowers undiluted by bright sunshine. Early-morning and late-afternoon lighting conditions create beautiful and interesting reflections of flowers in the water.

Areas near bodies of water lend themselves to sweeping vistas. As a result, you might want to use a wide-angle lens. This will let you move in close to coastal flowers, such as irises, roses, and lupines, and still show the surrounding seashore or lake. Keep in mind that when you shoot panoramas, you must be sure that the horizon line is absolutely straight.

Finally, when you shoot in wetlands and coastal areas, you need to protect your lens from salt in the air and water with a skylight or haze filter. Store your various pieces of equipment in zip-lock bags for extra protection when you aren't working with them. Use a camel's-hair brush and a rubber bulb blower to clean out all parts of the camera at the end of each day. Avoid using canned air to do this; it can force dirt particles into the camera's mechanism and can destroy the valuable multicoating on lenses. Then use lens tissue as necessary.

WOODLANDS AND FORESTS

As soon as the snow begins to melt, the forest floor comes alive with mosses, ferns, and early-spring wildflowers. Flowers emerging through snow make particularly fascinating pictures. With the exception of flowers in tropical rain forests, woodland flowers tend to bloom before a

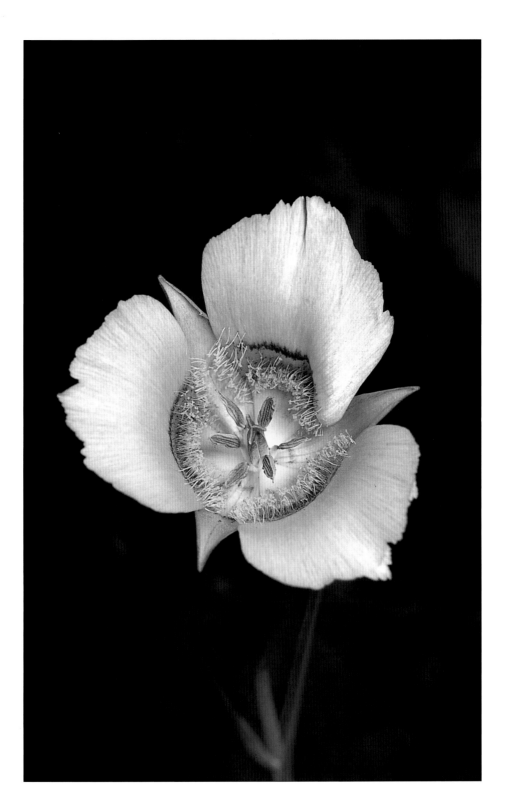

Here, an overcast day diffuses the woodland light, thereby enriching the color of these bleeding hearts. The lighting conditions also made it easier for me to separate them from their tangled surroundings. Shooting at New York's PepsiCo World Headquarters with my Olympus OM-3 and my Zuiko 50mm macro lens on a tripod, I exposed for 1/60 sec. at f/4 on Fujichrome 50 RF film.

thick canopy of leaves grows and keeps the lower reaches in deep shade. The length of the shooting season in these settings depends on the location, but the minimum time span is two weeks. This period can, of course, last for several months.

When you prepare to shoot in these locales, you need to think about making three different kinds of pictures: intimate landscapes in which the flowers and their immediate environment are integrated, floral portraits in which the frame is filled with one or more flowers, and closeups in which details dominate. You must also be aware that shooting flowers in forests and woodlands poses a challenge. Composing floral portraits in these areas isn't easy because backgrounds can contain so many distracting elements.

Whichever type of photograph you're making, then, you must keep the background simple and as far away from your subject as possible. Woodlands tend to have a tangled confusion of twigs, leaves, rocks, branches, and trees that don't make rewarding backdrops if you don't

weave these potential distractions together very carefully. Unless you want these background elements to be part of your design, you should eliminate them in one of several ways: by composing in a direction that is less problematic, by taking advantage of contrasty light conditions and leaving the tangled backdrop in the dark, or by throwing the background out of focus through the use of a wide-open aperture or a telephoto lens.

Unfortunately, the dappled light that is so appealing about a woodland setting on a sunny day makes photographing there very difficult. A simple solution is to shoot in the woods on overcast days when the light is more uniform. This approach is especially helpful for panoramic images. If, however, your shooting schedule doesn't permit you to wait for overcast conditions, select floral subjects that are completely in shade, and then frame your shot carefully so that no bright spots in the background distract from your subject. Shade offers low-contrast conditions and good color saturation.

Another option is to spotlight an individual flower or a grouping with a shaft of bright light, thereby letting the surroundings go dark to create a dramatic backdrop. This technique is quite effective when the flowers are sidelit or backlit. Alternately, some wildflower photographers use diffusion tents to cope with bright sunshine in the forest. They simply place the tent, which is made of opaque plastic, over the flower or plant they're photographing in order to soften the illumination.

Finally, you should keep in mind that on sunny days, photographs shot in wooded areas tend to have a bluish cast. This is quite apparent in pictures taken at the edge of the forest. Therefore, as a precaution, use a skylight or a warming filter to neutralize the blue, which is difficult to detect. Be aware, too, that the low light level in thick forests may require you to use fast film, longer exposures, or an electronic flash. Furthermore, the ambient light found in deep shade may lack contrast, leaving flowers without definition or depth. Increasing the illumination with an electronic flash unit will add contrast and sparkle to your subjects. When used properly, fill-in flash gives flowers a natural look.

I made this floral portrait in Maine's Acadia National Park. While photographing this arrangement of bunchberries from above, I decided to fill the frame with them. A tripod was essential here because of the slow shutter speed needed for the dim woodland environment. Shooting with my Olympus OM-4T and my Zuiko 35mm wide-angle lens, I exposed Ektachrome 100 EPZ film for 1/15 sec. at f/11.

When shooting closeups, I scout out nearby rocks for desert flowers growing in the shadows, such as these California cactus flowers. The diffused light in the scene enriches their colors; it also made determining exposure much easier. Working with my Olympus IS-3 at its 35mm wide-angle-lens setting, I exposed for 1/60 sec. at f/8 on Fujichrome 100 RD film.

When shooting this vignette of poppies in the desert in Israel, I decided to eliminate the setting completely. I thought that emphasizing color and composition would result in a stronger image. I made this shot with my Olympus OM-2S and my Zuiko 180mm telephoto lens. The exposure was 1/500 sec. at f/4 on Kodachrome 64.

Panoramic vistas of fields of desert flowers work best at the extremes of the day. I made this shot of coreopsis at sunset in Death Valley, California, with my Olympus IS-3 camera and my 28mm wide-angle-lens adaptor mounted on a tripod. The exposure was 1/125 sec. at f/8 on Fujichrome Velvia.

DESERTS

Deserts bloom early in the growing season. In the American desert, such flowers as poppies, anemones, and desert gold bloom from early March through April. Cacti bloom three to four weeks later. Look for flowers on the desert floor, in dry riverbeds, along the slopes of hillsides, and in rock crevices when you shoot in the desert.

In general, the light is very bright within an hour or two after dawn on sunny days. Therefore, in order to successfully capture the soft, low-angled illumination of early morning on film, you should arrive at your photographic destination about half an hour before sunrise. If you miss this window of opportunity, plan to take pictures in the late afternoon as the sun sinks in the sky.

During the period in between these two times of day, the strong available light washes out details. This is an ideal time for you to scout potential locations. If, however, you must shoot in bright light, beware of hot, white areas in the background; these can dominate your floral subjects. Another potential problem is that the bright illumination of midday may make capturing panoramic views and other broad vistas too difficult.

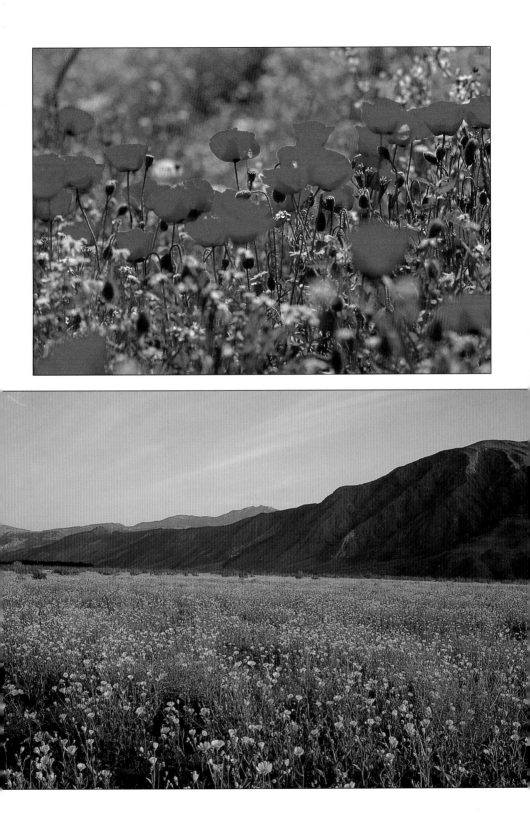

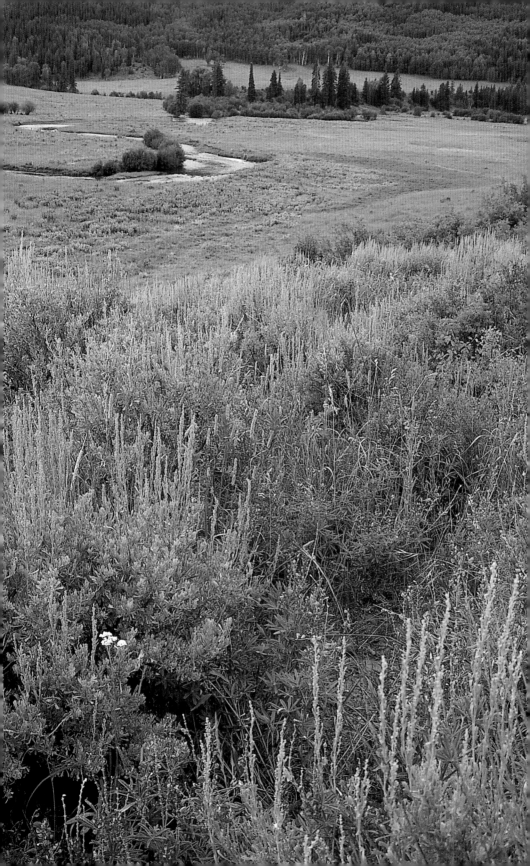

In these situations, you should try shooting vignettes and closeups, which eliminate most of the background in the scene. You can also photograph closeups of flowers that are growing in the shadows of rocks or other shaded areas.

Take advantage of any clouds that momentarily obscure the sun, briefly providing more uniform, muted light. You might also try incorporating interesting cloud formations in your compositions. A polarizer is invaluable for removing glare and reflections and for deepening the blue of the sky, thereby making clouds appear even more dramatic in the final images.

When you shoot in the desert, it is essential that you protect your lenses from blowing sand and grit with skylight filters. Clean your camera and all of your lenses once or twice a day, following the procedure you use for shooting in coastal areas and wetlands. Once again, use a camel's-hair brush and a rubber bulb blower to remove sand and grit; don't use canned air, which is potentially damaging. Use lens tissue as needed. Store your camera and lenses in zip-lock plastic bags to guard against the elements.

Although shooting in bright light poses many problems, there is at least one benefit. Working in this type of illumination lets you choose from a wide range of films. This is a good opportunity to work with both slow films and those with low contrast, such as Kodachrome 25, Fujichrome 50, Ektachrome 64X, and Ektachrome Elite 100.

HIGH MOUNTAIN ELEVATIONS

Alpine flowers, which grow at high elevations, are compact, tiny specimens that hug the ground and tend to blend in with their surroundings. They bloom as soon as the snow melts—sometimes even sooner—and a second bloom often follows later in the summer. The growing season for alpine flowers is, obviously, rather short, so if you're looking for particular

Capturing alpine wildflowers on film often requires hiking into relatively inaccessible areas, such as this high meadow in Colorado. I tipped my camera down to eliminate a dull-looking sky in this shot of a floral landscape filled with lupines and Indian paintbrush. Working with my Olympus IS-3 and its built-in 35–70mm zoom lens mounted on a tripod, I exposed Fujichrome Velvia for 1/30 sec. at f/16.

Time your shots when the light is most dramatic. This striking image of a floral landscape near Crested Butte, Colorado, became possible when the sun briefly shone both on the foreground sunflowers and on the winding river in the valley below. I mounted my Olympus OM-4T and my Zuiko 35mm wide-angle lens on a tripod and then exposed Fujichrome 100 RD film at f/11 for 1/30 sec.

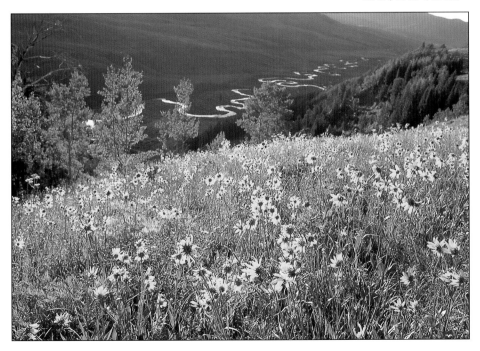

Choose your film carefully for mountain photographs. I made this shot of Indian paintbrush with Ektachrome Elite, a new film. Its warming qualities counteract the blue tones found at high elevations. Shooting in Colorado with my Olympus OM-4T and my Zuiko 90mm macro lens mounted on a tripod, I exposed for 1/125 sec. at f/5.6 on Ektachrome 64 Professional EPX film.

I made this closeup of a Colorado columbine with a lightweight point-and-shoot camera. This type of camera is a wonderful choice when you're hiking and you want to minimize your gear. Here, after mounting my Olympus IS-2 and my IS/L closeup adaptor on a tripod, I exposed Fujichrome Velvia for 1/125 sec. at f/5.6.

specimens, consult knowledgeable people in the area about the variations that inevitably occur from year to year.

Alpine flowers often emerge first at lower elevations and then gradually work their way up the mountain as the growing season progresses. Therefore, if you miss the early-spring bloom at 6,000 feet in June, you may get similar blooms at 9,000 feet in July. At the higher elevations, snow may be on the ground throughout the summer, and spring may not arrive until mid-July. Flowers capped with snow from a spring snowstorm are rare and highly marketable, so keep an eye out for them.

A good rule of thumb is to search areas of recent snow melt for new alpine blooms. It is possible to find alpine flowers in the high passes of most mountain regions around the world as late as mid-August. Rocky outcrops, sheltered ledges where humus accumulates, springs, streams, and sphagnum bog (spongy soil) are other good places to look for the unique plants and flowers that grow in alpine regions.

Photographing at high elevations often requires hiking into relatively inaccessible areas. Although you should choose your gear with weight limitations in mind, you must carry the essentials in order to make your outing worthwhile. By all means, bring along a lightweight tripod with a short centerpost, so you can get close to the ground. Also, bring your closeup equipment. In order to photograph typical alpine flowers at high elevations, you'll need a macro lens and extension tubes. In addition, you should bring a 35–70mm zoom lens to shoot floral landscapes, an ultraviolet filter to reduce haze, a warming filter to counteract the blue tones, and plenty of film—four or five rolls per day—so that you won't run out.

Lighting conditions tend to be very erratic at high elevations. Be prepared for rapid changes in the illumination: bright and warm one minute, gloomy and cold the next. Make the most of interesting lighting juxtapositions. For example, the area near you may be in bright sunshine while dark clouds are visible in the distance. Such combinations photograph very dramatically, especially with colorful flowers in the foreground. Exercise patience, and time your shots carefully.

Finally, be sure to carry a windbreaker or rain slicker in your backpack. At high elevations, you'll find that winds whip up regularly. Furthermore, storm clouds can gather quickly.

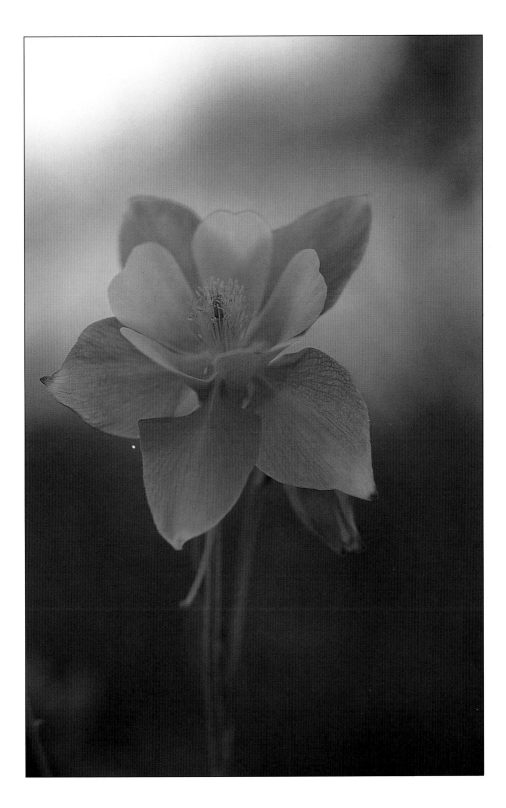

Appendix: Flash Determinations

FILL-IN FLASH

In order to eliminate or soften shadows on flowers, outdoor photographers find an electronic flash unit to be a versatile accessory. They can set the flash unit either to provide just enough fill-in light to show detail in the shaded areas without eliminating shadows, or to avoid shadows entirely. Fill-in flash is best when used between 3 and 15 feet from the subject.

Because there are so many camera-and-flash systems on the market, it isn't possible to give specific instructions for each. However, the principles and steps listed below provide a general guide to the effective use of fill-in flash.

FOR FLASH UNITS WITH VARIABLE POWER RATIOS:
1. Set the flash unit to the proper film-speed designation, for example, ISO 100.
2. Set the camera shutter speed to the designated flash-synchronization speed. Most cameras synchronize at 1/60 sec.or slower.
3. Carefully meter the highlights, that is, the brightest parts, of the flower, with the camera's shutter speed set at the synchronization speed for flash photography.
4. Focus on the subject to determine the flash-to-subject distance. You'll find this distance on the focusing scale of the lens barrel.
5. To determine the flash output for this distance, set the flash unit for manual operation. Turn the dial on the flash unit so that the flash-to-subject distance and the highlight meter reading are aligned. An arrow or indicator will point to the suggested power level.
6. You then need to reduce this power level by one f-stop for the purpose of fill-in flash. Simply use the next lower power level for the one suggested. For example, if the meter reading is ƒ/11 and the flash-to-subject distance is 9 feet, the recommended power level may be one-half power. For fill-in flash, set the flash unit at one-quarter power.
7. Take the photograph. Bracket by changing the f-stop at half-stop intervals.

FOR FLASH UNITS WITH CONSTANT POWER OUTPUT:
1. Set the flash unit to proper film-speed designation, for example, ISO 100.
2. Set the camera shutter speed to the designated flash-synchronization speed. Most cameras synchronize at 1/60 sec. or slower.

3. Carefully meter the highlights, that is, the brightest parts of the flower, with the camera's shutter speed set at the synchronization speed required for flash photography.
4. Focus on the subject to determine the flash-to-subject distance. You'll find this distance on the focusing scale of the lens barrel.
5. The dial on the flash unit will recommend a particular f-stop at this flash-to-subject distance. Compare the recommended f-stop to the meter reading.
6. If the meter reading and recommended f-stop are the same (e.g., 1/60 sec. at f/8), or if the meter reading calls for a higher f-stop than the one suggested on the flash-unit dial (e.g., a meter reading of 1/60 sec. at f/16 and a recommended f-stop of f/8), you can reduce the power output of the flash unit in one of two ways:

 a. by covering the flash unit with layers of lens tissue to achieve the desired reduction of light output.

 b. by removing the flash unit from the camera and placing it at a greater distance from the subject.
7. If the meter reading calls for an f-stop that is one stop lower than the one recommended on the flash unit (e.g., the meter reading is 1/60 sec. at f/11, and the recommended f-stop is f/16), then no compensation is needed, and you can go ahead and take the photograph.
8. If the meter reading calls for an f-stop that is two or more stops lower than the lower one recommended on the flash unit (e.g., the meter reading is 1/60 sec. at f/11, and the recommended f-stop is f/22), then move the flash unit closer to the subject.
9. Another way to reduce power with fill-in flash is to increase the film-speed number (ISO) on the flash unit or on your camera if it controls the flash output. This change fools the built-in, computerized electronic mechanism into producing less illumination based on the assumption that a faster film is being used. Doubling the ISO number is equivalent to a reduction of one full f-stop. You can make intermediate reductions proportionately.
10. You can also reduce light output by covering the flash head with two sheets of lens tissue. The loss of light will be approximately one f-stop. The resulting image will show little change in the background lighting, but the shadows in the foreground will be brightened.

FLASH TEST

The flash test below is designed to help you control the light output on an electronic flash unit for proper exposure in closeup photography. Since most flash units are too powerful at close range or at a distance of less than 3 feet, you need to reduce light output. You can achieve this by applying layers of lens tissue over the flash head. The flash test will guide you as to how many layers are required with the flash unit at hand, and is meant only for magnifications of one-sixth life-size to full life-size.

EQUIPMENT AND MATERIALS

1. A 35mm SLR
2. A macro lens or extension tubes with automatic diaphragms.
3. A flash unit with manual controls. The ideal flash unit should be light and inexpensive, accept interchangeable batteries, and have a guide number ranging from 30 to 50. Larger, more powerful units used for fill-in flash aren't recommended for this test or for closeup photography.
4. A tripod.
5. A package of lens tissue and rubber bands.
6. Any slide film in the ISO 25 to 100 range. Kodachrome 64 and Fujichrome 50 work best. Slide film is best here because it accurately records the minor changes in exposure that are critical for this test. If you use negative film, you must arrange for a professional lab to process the film and make a color contact sheet of the test roll after the test is done as described earlier. Don't have standard 3 x 5-inch commercial prints made because they won't show the exposure variations necessary to get the proper exposure.
7. A power cord (PC) that enables you to remove the flash unit and fire it off the camera.
8. A chart to record exactly what you'll be doing for future reference. On the chart you should identify the type of film and list numbers from 1 to 24 or to 36 that match the number of exposures on the roll of film. Next to each number, record the general color intensity of the flower—light, medium, or dark—and the number of sheets of lens tissue on the head of the flash unit.

PROCEDURE

1. Place the camera on a tripod, and select three flowers for the exposure test: A light-colored variety (for example, a lily), a dark-colored variety (for example, a red rose), and a medium-colored variety (for example, a morning glory). You'll shoot a series of test exposures for each flower.

2. Be sure that the flower to be photographed is at magnification of half life-size, which is the maximum magnification on most macro lenses. Focus very carefully on the part of the flower that is most crucial for sharpness.
3. Set the lens aperture at f/16 or one stop down from the smallest aperture. For example, if the smallest aperture is f/22, use f/16; if it is f/16, use f/11.
4. Connect the flash unit to the camera using the PC cord. Holding the flash unit off the camera, position it so that it is parallel with the front edge of the lens, and is at a 45-degree angle to the flower. (A number of manufacturers, such as Olympus, Spiratone, and Novoflex—make special brackets for mounting the flash to the front of the lens, thereby simplifying such closeup flash photography.) Positioning the flash at exactly the same place isn't critical because a slight movement off the mark will still result in proper exposure. What is very important is that you point the flash directly at the flower.
5. Release the shutter to fire the flash.
6. Continue taking photographs of the same flower, adding one piece of lens tissue at a time, up to seven sheets. Make sure that the lens tissue covers the head of the flash unit to reduce light output effectively. Use rubber bands to secure the lens tissue. Repeat the same procedure with all three flowers.
7. Process the film normally.
8. The preferred method for reviewing slides is to lay them out on a lightbox in the order in which you shot them. View them with a 4x magnification loupe. The photographs will appear progressively darker because each layer of lens tissue reduces the light output of the flash unit. Select the best exposure for each flower. Refer to your chart to determine how many pieces of lens tissue you used on the flash unit for that particular shot.

If you don't have access to a lightbox, critique your slides by projecting them onto a pure white wall. On each slide write down the number of pieces of lens tissue used, and file the slides for future reference.

If the test has been successful, you'll need to use more pieces of lens tissue to get the proper exposure for the light flower than for the darker flowers. If this isn't the case, you'll know that you did something improperly and should repeat the test.

Once you've successfully repeated the test and selected the best exposure for each flower, you'll be able to replicate your results as long as the magnifications of your subject stay between one-sixth life-size and full life-size. For the most critical exposures, bracket all shots by half-stop intervals.

Index

Acadia National Park, 119
Alpine wildflowers, 122, 123
Anemones, 83
Anza Borego State Park, 1, 13, 14, 15, 16, 17, 46, 63, 80, 86, 88, 98
Arizona, 103
Aspen grove, 116
Asters, 17
Azaleas, 43, 54, 55

Baker Island, 114, 115
Bar Harbor, Maine, 15, 66, 67, 114
Bleeding hearts, 118-119
Bluebells, 54, 55
Borage family, 91
Brazilian orchids, 32, 33
Brittlebrush, 88
Bronx, New York, 32, 33
Bugloss, 91
Bulb field, 33, 34-35
Bulb garden, 52, 53
Bunchberries, 119

Cactus flowers, 120
Cactus lilies, 29, 30
California, 1, 13, 16, 17, 37, 40, 41, 46, 54, 63, 80, 81, 88, 94, 98, 105, 120, 121
Canola field, 59
Cherry blossoms, 77
Chrysanthemums, 49, 69, 106, 107
Cleomes, 71
Clovers, 24, 25
Colorado, 9, 23, 33, 38, 39, 46, 47, 67, 72, 76, 84, 85, 91, 99, 110, 111, 116, 122, 123, 124, 125
Columbines, 33, 124, 125
Coneflowers, 45, 48, 49
Coreopsis, 13, 16, 24, 105, 120, 121
Crested Butte, Colorado, 9, 23, 110, 111, 123
Crocuses, 102, 103

Daisies, 6
Dandelions, 46, 47
Day lilies, 22, 78
Death Valley, 13, 14, 15, 16, 24, 63, 81, 94, 98, 105, 120, 121
Delaware, 54, 55, 60, 61, 63

East Mojave Desert State Park, 24, 54

Echium bugloss, 91
Emperor plants, 85
Evening primroses, 86, 98

Fairy dusters, 63
Fireweed, 67
France, 59, 87

Gentians, 98, 111
Grape hyacinths, 51, 52, 53, 58, 100-101
Grasses, 45
Ground-cover flowers, 52, 53

Holland, 2-3, 12, 28, 33, 34-35, 42, 51, 52, 53, 58, 59, 68, 75, 77, 85, 88-89, 95, 100-101
Hyacinths, 51, 52, 53, 58, 100-101
Hydrangeas, 96

Illinois, 27
Indian paintbrush, 38, 39, 67, 72, 81, 84, 85, 116, 122, 123, 124
Irises, 27, 65, 114, 115
Israel, 6, 57, 71, 83, 90-91, 120, 121

Jerusalem, 83

Kansas, 20, 21
Keukenhof Garden, 100-101

Lavender, 87
Lilies, 22, 29, 30, 32, 33, 78
Lisse, Holland, 12, 52, 53, 68, 100-101
Longwood Gardens, 32, 33, 96
Loosestrife, 41
Lupines, 24, 44, 54, 56, 64, 66, 67, 72, 74, 99, 110, 111, 112, 113, 122, 123

Magnolias, 10
Maine, 15, 24, 25, 44, 56, 64, 66, 67, 74, 92, 93, 94, 112, 113, 114, 115, 119
Mallows, 40, 41
Mariposa tulips, 116, 117
Mojave Desert, 81
Montclair, New Jersey, 65
Morning glories, 93
Morton Arboretum, 27
Mountain columbines, 33
Mustard family, 94

New Jersey, 65
New York, 8, 9, 17, 30-31, 32, 33, 43, 49, 50, 62, 82, 93, 106, 107, 118-119
The New York Botanical Garden, 5, 10, 17, 18-19, 22, 26, 27, 29, 30, 36-37, 46, 47, 65, 73, 78, 79, 97, 102, 103, 104, 106

Ohio, 43, 45, 48, 49, 60
Old Westbury Gardens, 49, 106, 107
Olive grove, 90-91
Orchids, 26, 27, 32, 33, 46, 47, 65, 109

Pansies, 43
Peas, 82
Pennsylvania, 32, 33, 96
Peonies, 15, 60, 73, 97
PepsiCo World Headquarters, 8, 9, 30-31, 50, 62, 118-119
Perennials, 30-31
Petunias, 69
Poppies, 6, 37, 57, 90-91, 103, 108, 120, 121
Primroses, 1, 80, 86, 98

Rocky Mountains, 84, 85
Roses, 36-37, 70, 92, 93, 106, 114

Sage, 38, 39
Sunflowers, 9, 20, 21, 23, 99, 110, 111, 123

Texas, 108
Thistles, 76
Tulips, 2-3, 5, 8, 9, 12, 17, 18-19, 28, 42, 50, 51, 53, 59, 60, 61, 62, 68, 75, 79, 85, 88-89, 95, 100, 116, 117

Verbena, 14, 15, 80, 86

Wallflowers, 94
Water lilies, 32, 33
Wave Hill, New York, 82
Wild roses, 114
Winterthur, Delaware, 54, 55, 60, 61, 63
Wisconsin, 53

Zinnias, 104